Over, In, an <!-- text partially obscured by barcode --> D0362143

Over, In, and Under

Emma Bolland

Dostoyevsky Wannabe Experimental
An Imprint of Dostoyevsky Wannabe

First Published in 2019
by Dostoyevsky Wannabe Experimental
All rights reserved
© Emma Bolland

Dostoyevsky Wannabe Experimental is an imprint of
Dostoyevsky Wannabe publishing.

Cover design by Dostoyevsky Wannabe
Copyedited by Graham Paul Donovan

dostoyevskywannabe.com
ISBN-9781792687136

Contents

Preface

The four texts that comprise this collection consider processes of speaking, writing, reading, and remembering.

'Over, In, and Under: after Über Deckerinnerungen' is an 'expanded translation' of Sigmund Freud's 1899 essay 'Über Deckerinnerungen', translated in English as 'Screen Memories'. Freud posits a screen memory as a memory that stands in for, or covers another, more traumatic memory. My 'translation' was a process of free association, appropriating a psychoanalytical method to construct an anti-rational narrative of memory as presence that strikes through the authority of the original text. My words were suggested to me by the sounds and shapes of the German, and constrained through an adherence to the original punctuation. The German text with which I worked was a facsimile of an early publication downloaded from the Internet, which, on conversion to Word, was subtly transformed in a digital mis-reading of the High German characters, often replacing them with coded clusters of punctuation marks—a digital subjectivity began the translation for me. The word choices I made, consciously and unconsciously, as both subject and writer, were further produced *via* experience, a fondness for certain kinds of imagery over others, and the increased nurturing and seeking out of this imagery as the 'translation' unfolded. A further impossibility was the suppression

of my familiarity with Freud's essay, and the equal impossibility of forgetting the little German I know: 'Ich' is often 'ice', but sometimes insists on the 'I'. Unlike 'Über Deckerinnerungen', in 'Over, In, and Under' there are no propositions, arguments, theories, scenarios, beginnings, or endings to be found. Instead, there is an iteration of a violent poetry of flashback and self-apocalypse. I subtitled my first draft as 'a hysterical translation without a dictionary', but on completion I altered the subtitle to 'a psychotic translation without a dictionary', as 'psychotic' more accurately captures the text's persecutory and enclosed scenario, and the ways in which psychosis displaces meaning.

The other three texts, in different ways, also employ direct and indirect allusions to psychoanalysis. 'Violet', an auto-fictional and hallucinatory framing of 'the city', undertakes a dream-reading of Jacques Lacan's essay 'Seminar on The Purloined Letter', which itself is an analysis of an Edgar Allan Poe detective story. The accompanying endnotes are intended to be part of the narrative, rather than simply a referential supplement. 'Manus' considers the relations between speaking, memory, and post-trauma, *via* screenwriting and Twitter pornography. 'Poor Wee Monster' employs the forgetting of Mary Shelley's Frankenstein to consider the monstrous self.

Over, In, and Under:
After *Über Deckerinnerungen*
(a psychotic translation without a dictionary)

I

~~Im Zusammenhange meiner psychoanalytischen Behandlungen (bei Hysterie, Zwangsneurose u.: _a.) bin ich oftmals in die Lage gekomme~ mich um die BruchstUcke von /Erinnerungen zu bekUmmern, die den einzelnen aus den ersten Jahren ihrer Kindheit im Gediichtnisse geblieben sind. Wie ich. schon an anderer Stelle angedeutet habe, muB man fUr die Eindrucke dieser Lebenszeit eine groBe pathogene Bedeutung in Anspruch nehmen. Ein psychologisches Intereli&e aber iSt dem Thema, der Kindheitserinnerungen in allen Fiillen gesichert, well. hier eine fundamentale Verschiedenheit zwischen ·dem psychischen Verhalten des Kindes und des Erwachsenen auffiiili.g zutage tritt. Es. Bezweifelt niemand, daB die Erlebnisse unserer ersten . Kinderjahre unverl&·chbare Spuren in unserem Seeleninnern zurUckgelassen haben; wenn wir aber unser Gediichtnis befr~ welches die Eindrucke sind, unter deren Bruwirk'ung von /an unser Lebensende zu stehen uns bestimmt ist, · so liefert es entweder nichts oder eine relativ kleine Zahl vereinzelt stehender Erlnnerungen von oft fragwUrdigem oder riitselhaftem Wert. DaB das Leben vom Gediichtnis als zusammenhiingE!nde Kette von Begebenheiten reproduziert wird, kommt nicht vor dem sechsten oder siebente~, , bei vielen erst nach dem zehnten Lebensjahr zustande. Von da an ~llt sich aber auch eine konstante Beziehung zwischen der psychischen Bedeutung eines Erlebnisses und dessen Haften im Gediichtnis her. Was vermt! ge seiner unmittelbaren oder bald nachher erfolgten Wirkungen wichtig erscheint, das wird gemerkt; das fUr unwesentlich Erachtete wird vergessen. Wenn ich mich an eine Begebenheit Uber lange Zeit hin erinnern kann, so finde ich in der Tatsache dieser Erhaltung im Gediichtnisse einen Beweis dafUr, daB· dieselbe mir damals einen tiefen Eindruck gemacht hat. Ich pflege mich zu wundern, wenn ich etwas Wichtiges vergessen, noch mehr vielleicht, wenn ich etwas scheinbar GleichgUltiges bewahrt haben sollte.~~

Together hangs my psychic hand-breath (hysterical swinging neurotic), I am so often come to the lake, me at the breast beginning and beckoning, the only and the fearful year of the child in get-nothing is living.

'We are'.

We are beautiful and stars have doubt, we must for this one dread life be stung with grotesque pathos and spoken name. A psychic inter-life is thematic, the child times in and under, in the many searching weals. Be a fountain shame-hiding between those slighted halting children and the ears

that see the awful severed trust. It. Between nothing, there the early kiss is your first. Child-years unfurl and bare spurs have seeded in your glassed-over self; but when we betray our goodness, which is the first dread, under there hung one by our life thread and you stand behind it, so light that between nothing or the smallest time there exists the inner-under that will fragment gemstones of self-written words. Damn the life of goodness and togetherness! Catch and blast-heat the word, count nothing for the sighted and the sighing – be violent before the slighted stab of your life. There you are, sick beside a constant scythe between the psychotic beast of first kisses and those having goodness here. What vermin! With your unremitting badness of forgotten words, which shine, the word marked, the eradicated words that underwent forgetting. When I might for one brief but long time hide inside, so I find the taste of the halting goodness in the beast of the hour, that self-damned devil once made hated. I pledge myself to wonder when I wish to forget: no more light. When I was shining like the beast I was alone.

II

Erst in gewissen pathologischen Seelenzustiinden wird die fllr den normalen Erwachsenen gUl-
tige Beziehung zwischen psychischer Wichtigkeit und Gediichtnishaftung eines Eindruckes wied-
er gelt!st. Der Hysterische z. B. erweist sich regelmiiBig als amnestiscb fUr das Ganze oder einen
Teil jener Erlebnisse, die zum Ausbruch seiner Leiden gefnhrt haben, und die doch durch diese
Verursachung fllr ihn bedeutsam geworden sind oder es auch abgesehen davon, nach ihrem eige-
nen Inhalt, sein m<lgen. Die Analogie dieser pathologischen Amnesie mit der normalen Amnesie
fllr unsere Kindheitsjahre m<lchte ich als einen wertvollen Hinweis auf die intimen Beziehungen
zwischen dem psychischen Inhalt der Neurose und unserem Kinderleben ansehen. Wir sind so
sehr an diese Erinnerungslosigkeit der Kindereindriicke gew<lhnt, daB wir das Problem zu ver-
kennen pflegen, welches sich hinter ihr verbirgt, und geneigt sind, sie als selbstverstiindlich aus
dem rudimentiren Zustand der seelischen Tiitigkeiten beim Kinde abzuleiten. In Wirklichkeit
zeigt uns das normal entwickelte Kind schon im Alter von drei bis vier. Jahren eine Unsumme
hoch zusammengesetzter Seelenleistungen in seinen Vergleichungel), SchluBfolgerungen und im
Ausdruck seiner Gefilhle, und es ist nicht ohne weiteres einzusehen, dci.B ffir diese, den spliteren
so voll gleichwertigen, psychischen Akte Amnesie bestehen muB.

Her whispered pathos sees lust in words that float the
ghost-wishing of gilded beasts between sightless witching
and godless shaft-hung dried unwieldy guilt! Stay. The
hysterical omega being watched while she wrested amnesia
from the gaze of another jealous tale of early kisses, the
sun once again breaking its light and then through these
venomous flowers their blasted words are other and
absented upon, but their eyes halt, their mouth-eyes. The
agonised pathology of this amnesia with the numbered
nemeses floating through the child year my light is also
a word full of the hidden white of the intimate beast
between the psychic halting of the new rose and unseen
child life seen. We are so sore and these inner-under losses
cut the childlike-lick grown thin. That was the problem to

know flight, which the hinterland forgives, and denies you, this self that stands like the first stand that stands laughing at the absolute child. In word-work sighs the normal wicked child shines in the other stratosphere. Years consumed together seen and stung in your word-like angel, psychic aches amnesia must distil.

III

An unlit foreboding follows the beast-biding psychic problem, and had the first child-inner-under fucked, where nature licked the sad lungs of material, in them made through hum-fear felt, was flower fading on this love-sight a grim beast angry for names watching with misshapen vermillion. A first shrill then this rictus is vicious. He never ate though the first kiss forbidding one and herein fractal bones gobbled; the over all unregarded first kiss, the unfearing of worlds. Four hundred dry stars, parsing and words unleafing, words then for the bed eaten late in night and heaven in lauded sacrificial vermillion light. (Enquire for the highest remembrance of the infant.) That mirror goes wording the absent finished light, the scheme in signs will stand in kindest hands, words I might with heaven hung jealousy whip past beginning, for damned am I for iron-flying there with mirrors so gendered dread inner-under gelatinous cunt.

IV

The life-salt, in which the halted frost of child-innards forgot words, is moist, the time switching two and fro the years (so be ache-dreads perceived in the beast-stings of endings). It gives above oneself, there gives it whiter suck wracked selfish in the alter-foreboding damned following hurting jar, and other people by their frightful inner-under first of dexterous sex, sobbing, the aching jar is damned. Womb desire divided varnished-shitted-beast sang suck hammer-singed, live such fore-licking night again; man bent over saying the heinous, dancing the penis, there frosting the inner-under in searing scarring other-flight, it was in the first living years, ache the winter whiter self-salting inner-under over the lighted jars of fog, and dazzle the production of first life and a fortressed interior by the single frozen terminus – it was from frozen years, abhorred

by others, damned first other – in a spitting salt it flies. It is also night near the sore-pointed flower of the ache-treading of the first inner-under, condemn the gaze fuck the inner beast prism forgetting and splitting.

V

I gaze beyond intercession words that freeze the world,
which dare hate this fleeing child-heart-inner-under supine
flight. I double you scything the waiting mist-man the
helling merman, that awful dead stuff of living ache drilling
and making sweat of all words, witching and mazing after
hover hard and dark ears follow bad nature as bed-stained
her cut words sin. I lie there for the heavy gossamer ever-
under shames these warning aches to your beast-eating,
then sigh feel all this heart-stone inbreath the first keen hot
in-and-under one sigh and lick the first, be-shitted, corpse-
shitted you. Diving, always sighing with beast-heat, with
cracked heart, death-fall, brine, burned with ghosting you,
you. Aches. Many will sicken getting and naming, dazing
and pinching the gnawing and wailing following the child-
seer denied.

'My sighs will follow the wake'.

It is night universe. Endless, always dark ache-drilling and waning words, dark death halting child-heat in-and-under ice sore dark follows a bleeding end. Listen, for the world ends! I seek the intercession of the children for YOU never shine on those whom the waking hate. So early. Damned light, dreaming, dazing. Breathe. A pen withheld, therein sees all the Other with two ears and a shining fall, the hearing poppies sugaring sin, sighing for amnesiac flowers, the first and tearful ice-kiss, there the damned waking come.

VI

I see nothing in the snow. Frosted gems souls only wailing
and mud grinding beast-frozen half-rivers, when we hear,
dreamed by mauled penitents the freezing child heat in-
and-under all tender and glass-tender and ice-driven
through hateful arbours, the beast lives in the after-words
aching the child night falls counting, and the dark maims
all. Dark tails. Men must sever! Sharp, marked words sting,
wicked and glass-sharp icy night in jealous hating words,
salting when they ache damned souls the old sinning-time
of children intent grieving beasts. So sighs heaven when
the confessor the defiler, the first inner-under, in the time
stinging dark and vile ears forgotten, he the beast-bedecked
tear-time, of the first schism made ice star. In this time flies
aching death shines growl-mutters, there the kind night
outshines the lantern's sore earth. O. Hated. The numbers

confess the defilement while all nights are your death-falls,
inverted sick of the time-nurtured schism of ice.

VII

A wanderer bereft and thirsty child-hot in-and-under an episode with a space-gang, of them and for them who are born in a star-boat. Her night gleamed hailing angels as cunts, a world orb falling.

'He swears my pens with diamonds, and a lace of hells'.

~~Henri bezeichnen solche Fälle als selten vorkommende; nach meinen—allerdings zumeist bei Neurotikern gesammelten—Erfahrungen sind sie häufig genug. Eine der Gewährspersonen der Henri hat einen Erklärungsversuch · für diese ob ihrer Harmlosigkeit unbegreiflichen Erinnerungsbilder gewagt, den ich für ganz zutreffend erklären muß. Er meint, es sei in solchen Fällen die betreffende Szene vielleicht nur unvollständig in der Erinnerung erhalten; gerade darum erscheint sie nichtssagend; in den vergessenen Bestandteilen wäre wohl all das enthalten, was den Eindruck merkenswert machte. Ich kann bestätigen, daß dies sich wirklich so verhält; nur würde ich es vorziehen, anstatt ,vergessene Elemente des Erlebnisses' ,weggelassene' zu sagen. Es ist mir oftmals gelungen, durch psychoanalytische Behandlung die fehlenden Stücke des Kindererlebnisses aufzudecken und so den Nachweis zu führen, daß der Eindruck, von dem ein Tor&O in der Erinnerung verblieben war, nach seiner Ergänzung wirklich der Voraussetzung von der Gedächtniserhaltung des Wichtigsten entsprach. Damit ist eine Erklärung für die sonderbare Auswahl, welche das Gedächtnis unter den Elementen eines Erlebnisses trifft, allerdings nicht gegeben; man muß sich erst fragen, warum gerade das Bedeutsame unterdrückt, das Gleichgültige erhalten wird. Zu einer Erklärung gelangt man erst, wenn man tiefer in den Mechanismus solcher Vorgänge eindringt; man bildet sich dann die Vorstellung, daß zwei psychische Kräfte an dem Zustandekommen dieser Erinnerungen beteiligt sind, von denen die eine die Wichtigkeit des Erlebnisses zum Motiv nimmt, es erinnern zu wollen, die andere aber—ein Widerstand—dieser Auszeichnung widerstrebt. Die beiden entgegengesetzt wirkenden Kräfte heben einander nicht auf; es kommt nicht dazu, daß ~ eine Motiv das andere—mit oder ohne Einbuße—überwältigt, sondern es kommt eine Kompromißwirkung zustande, etwa analog der Bildung einer Resultierenden im Kräfteparallelogramm. Das Kompromiß besteht hier darin, daß zwar nicht das betreffende Erlebnis selbst das Erinnerungsbild abgibt—hierin behält der Widerstand recht—wohl aber ein anderes psychisches Element, welches mit dem anstößigen durch nahe Assoziationswege verbunden ist; hierin zeigt sich wiederum die Macht des ersten Prinzips, welches bedeutsame Eindrücke durch die Herstellung von reproduzierbaren Erinnerungsbildern möchte. Der Erfolg des Konflikts ist also der, daß anstatt des ursprünglich berechtigten ein anderes Erinnerungsbild zustande kommt, welches gegen das erstere um ein Stück in der Assoziation verschoben ist. Da gerade die wichtigen Bestandteile des Eindrucks diejenigen sind, welche den Anstoß wachgerufen haben, so muß die ersetzende Erinnerung dieses wichtigen Elements bar sein; sie wird darum leicht banal ausfallen. Unverständlich erscheint sie uns, weil wir den Grund ihrer Gedächtniserhaltung gern aus ihrem eigenen Inhalt ersehen möchten, während er doch in der Beziehung dieses Inhalts zu einem anderen, unterdrückten Inhalt ruht. · Um mich eines populären Gleichnisses zu bedienen, ein gewisses Erlebnis der Kinderzeit kommt zur Geltung im Gedächtnis, nicht etwa weil es selbst Gold ist, sondern weil es bei Gold gelegen ist.~~

Aah inner beast-time solitary flower all souls command; not
mine – old things made moist by nervous gossamers: far
flung are the half-ghosts. Only the ghost-prick of heaven
has an evil suck – follow these old evils harming lost heat

and un-grieving the inner-bleeding ghoul, then with FURY gaze at suffocating licking MUD. Ermine, it sighs in sorrow filling the betrayed scene violet now understanding the inner-under it holds. Gaze down and shine your night-sage; in the forgetting beast-tales wails all that is enthralled, when the first-struck muck-sweat was made. I can be still, there dies such weary suffering; no words I can foresee, static, forgetting elemental early kisses.

'Wake up, you say'.

He is mirror opening my lungs, through a sighted fissure behind the velvet slips the childish kisses of sucking and sodomy night-white in fear, there the first strike, for demons torn and OH in the inner-under bleeding warm, night sees air stung wordless there voracious on the dick-hung white-stone unspoken. Damned is your earthly FURY for the sun burns your walls, where the Godless under the elements own loveless trysts, all things night will give you; madness which is earth frozen, wailing giants of beasts a-hunting, the lightened halted word. You are early and late my first, while mean thieves in mechanical ships forge iron-dread; men build such demons in the fucking stars, drained spectral cyborgs carving and suturing these

innards' bleeding signs, from day to a wicked night these first kisses surmount me, insides swollen, the hands of others – ice whiteness – distant out-singing wilderness. The hooded entangled words crisscross heaven in endless nightfall; he comes night dazes, DAZES – a mirror of hands – with only one eye – I willed it, slowly he comes one come, promise working sucking, it was always of blood trapped rusting in cruel parallelograms. That cunt promised beasts and dreaming, dazed was night. That beautiful first kiss silver lungs spilling and giving – here bleeds the wilderness – gold aberrant hands switching the elements, weaving those hands. Us. Beneath the dirt no hearts assuage forbidden kisses; here sings the widening night of the first promise, worlds bedecked with ice through the heart-stars foreswearing inner-under bleeding flux-maul! Ache. There fog is. Comets are also there, damned stars springing bereft in hands and innards stinging cunts, worlds gazing at stars STAR STRUCK in the asshole of forgetting. The growling whitened beast of the ice-djinn smiles, worlds of the ice-beasts waiting and heaving, so must the stars inside these white heavens be still; the words dreading light before the ache-fall. Understand he shines on me, while words ground into ice go sniveling and halting, grey as the eyes that see through shit, while here is the beast-hung demon inhaling through hands, until the hatred rests. You might hide poppies gladly in your bed, in the ice first-kiss the kind

hearts come to golden giving nothing – nothing, night that was wailing silver gold is only woe. Golden elegant ice.

IX

~~Unter den vielen möglichen Fällen von Ersetzung eines psychischen Inhalts durch einen anderen, welche alle ihre Verwirklichung in verschiedenen psychologischen Konstellationen finden, ist der Fall, der bei den hier. betrachteten Kindererinnerungen vorliegt, daß nämlich die unwesentlichen Bestandteile eines Erlebnisses die wesentlichen des nämlichen Erlebnisses im Gedächtnisse vertreten, offenbar einer der einfachsten. Es ist · eine Verschiebung auf der Kontiguitätsassoziation, oder wenn man den ganzen Vorgang ins Auge faßt, eine Verdrängung mit Ersetzung durch etwas Benachbartes (im örtlichen und zeitlichen Zusammen~ hange). Ich habe einmal Anlaß gehabt, einen sehr ähnlichen Fall von Ersetzung aus der Analyse einer Paranoia mitzuteilen. Ich erzählte von einer halluzinierenden Frau, der ihre Stimmen große Stücke aus der ‚Heiterethei' von O. Ludwig wiederholten, undzwar gerade die belang- und beziehungslosesten Stellen der Dichttu;~g. Die Analyse wies nach, daß es andere Stellen derselben Geschichte waren, welche die peinlichsten Gedanken in der. Kranken wach~ gerufen hatten. Der peinliche Affekt war ein Motiv zur Abwehr, die Motive zur Fortsetzung dieser Gedanken waren nicht . zu unterdrücken, 'und so ergab sich als Kompromiß, daß die harmlosen Stellen mit pathologischer Stärke und Deutlichkeit in der Erinnerung hervortraten. Der hier erkannte Vorgang: Konflikt, Verdrangung, Ersetz~ng unter Kompromißbildung kehrt bei allen psychoneurotischen . Symptomen wieder, er gibt den Schlüssel für das Verständnis der Symptombildung; es ist also nicht ohne Bedeutung, wenn er sich auch im psychischen Leben der . normalen Individuen nachweisen läßt; daß er bei normalen Menschen die Auswahl gerade der Kindheitserinnerungen beeinflußt, erscheint als ein neuer Hinweis auf die bereits betonten innigen Beziehungen zwischen dem Seelenleben des Kindes und dem psychischen Material der Neurosen.~~

Under the feeling, my gilded fearing for the first stung those ice-scythed halting hands, when all here were licking in weary wraith-shadows a psycho-witching constellating wind, icing the fall, there abiding by beast-child inner-under forgetting, that nimble dead unrelenting beast-entailer heinous and earnest the relentless dread early kisses betraying, offering only the ice-fucked star. It is my shaming and coruscating ascension for when men's gazes forwent their aching fast a dreadful arse-stung dirt was my benediction (licking and sight-spitting the unhung suck hammers – fear levitating tongues). I inhabit only

the animal heart, a sore and lilting fall from ice-tongues of the anal paranoiac mutilation. I exist on lies for your hallucinating freedom, that your stamen may grow stocky on the hetero-gods of shame. On ludic winds hovering over swearing rage I belong and beast stung I steal the Dick. I STEAL THE DICK. De-analysing the whitened nights, dull and angry stars enfold their selfish shivering wares, for which the penitents are thanking them. Cracked watches – regretful beds. Dreadful pain-licking was my motive for ascension, the motive for forgetting these thankless weightless nights. Too broken and too grasping that all is compromised, till the heartless stars with paths stark and doubtless carve out their ever hungry heaven. But he can't forgive: conflicted vendettas drain my guts, hurting under countless incomprehensible cuts beside my sighing nouns. Symptoms wriggle, he shuts them in slow castles that stand as symptom prisons; it is always night in our bedchamber, wanting such aches inside the shit-love of normality inverted into night-white ice; lullaby normality menacing the ache which grinds into the child hot inner-under beast-flight, it shines alone newly in white as the beast bestows inside between the sunless love the child and the psychic material of numb roses.

X

~~Die offenbar sehr bedeutsamen Vorgange der normalen und pathologischen Abwehr und die Verschiebungserfolge, zu denen sie fOhren, sind, soweit meine Kenntnis reicht, von den Psychologen noch gar nicht studiert worden, und es bleibt noch festzustellen, in welchen Schichten der psychischen Tatigkeit und unter welchen Bedingungen sie sich geltend machen. Der Grund fOr diese V ernachlassigung mag wohl sein, dall unser psychisches Leben, insofern es Objekt unserer bewuBten inneren Wahr~nehmung wird, von diesen Vorgangen nichts erkennen laBt, es sei denn in solchen Fallen, die wir als ,Denkfehler' klassifizieren, oder in manchen auf komischen Effekt angelegten psychischen Operationen. Die Behauptung, dall sich eine psychische Intensiiat von einer Vorstellung her, die dann verlassen bleibt, auf eine andere verschieben kann, welche nun die psychologische Rolle der ersteren weiterspielt, wirkt auf uns iihnlich befremdend, wie etwa gewisse Zilge des griechischen Mythus, wenn z. B. GI.Stter einen Menschen mit Schi.Snheit wie mit einer 1Hillle ilberkleiden, wo wir nur die Verkliirung durch verandertes Mienenspiel kennen. Weitere Untersuchungen ilber die gleichgilltigen Kindheitserinnerungen haben mich dann belehrt, daB deren Entstehung noch anders zugehen kann, und daB sich hinter ihrer scheinbaren Harmlosigkeit eine ungeahnte Fillle von Bedeutung zu verbergen pflegt. Hief!lr will ich mich aber nicht auf blolle Behauptung beschriinken, sondern ein einzelnes Beispiel breit ausfilhren, welches mir unter einer gri.SBeren Anzahl ahnlicher als das lehrreichste erscheint, und das durch seine Zugehi.Srigkeit zu einem nicht oder nur sehr wenig neurotischen Individuum sicherlich an Wert,. schatzung gewinnt.~~

They so often see the beautiful sadness falling towards malevolence and pathetic shame abstains until their viscous anger folds, then seafarers, sinning, sailing my cuntish rivers, condemned to the scissors of the night studied words, and she believes neither feelings nor stars, inhaling the shit of the psychic diktat until with wild bleeding she seeps golden mud. The grinding of her V enlarges the madness within, draws sore kisses labile, insolent as objects understanding bewitched inner worlds – no more words, for these forbidden nights can never last, except within her falling, there will be all, dick-fallen glass-

seared, glorious in mansions of comets flecked with angels' sightless operations. Thieves hoping that such eyes will scissor intensity through the iron interstellar ether, damned if they will believe inceptions from another angry shitting cunt, where waves roll silently below the first winter spells, words which illness befriended, whiteness knows nothing of the grim myths, when begging stuttering eyes mean that the mercy of men will sneer and retreat into the stone hills with laughing, where we gnaw at the vanishing words with angry and menacing knowledge. Whispered under-sucking silvers the guilt-gilded child-hot in-and-under howling with dangerous dirt, that dreaming and stinging knocks again at sugared cunts, and that sick winter I shone naked with harm's logic and unguarded filigrees of beautiful forbidden flight.

'Help Me!'

Will I mutilate night on bloody beheaded shrieking, sodomised with ice-eyes between bright augmentations, where moving under grimacing beasts my sore arse asks with a pain that shines, and the dirt seems like sugar in my eyes night after night sore and weeping tissues divided and sickly with words? Shame always wins.

XI

~~Ein achtund~reißigjähriger akademisch gebildeter Mann, der sich trotz seines femab liegenden B~s ein Interesse fûr psychologische Fragen bewahrt hat, seitdem ich ihn durch Psychoanalyse von einer kleinen Phobie befreien konnte, lenkte im Vorjahre meine Aufmerksamkeit auf seine Kindheitserinnerungen, die schon in der Analyse eine gewisse Rolle gespielt hatten .. Nachdem er mit der Untersuchung von .V~ und C. Henri bekannt geworden war, teilte er mir folgende zusammenfassende Darstellung mit: 'Ich verfolge über eine ziemliche Anzahl von frühen Kindheitserinnerungen, die ich mit großer Sicherheit datieren kann. Im Alter von voll drei Jahren habe ich nämlich meinen kleinen Geburtsort verlassen, um in eine große Stadt zu übersiedeln; meine Erinnerungen spielen nun · sämtlich in dem Orte, wo ich geboren bin, fallen also in das zweite bis dritte Jahr. Es sind meist kurze Szenen, aber sehr gut erhalten und mit allen Details der Sinneswahrnehmung gestaltet, so recht im Gege:t;lSHtz zu meinen Erinnerungsbildern aus reifen Jahren, denen das visuelle Element vi.Sllig abgeht. Vom dritten Jahr an ndre die Erinnerungen spürlicher und weniger deutlich; es finden lüch Lucken vor, die mehr als ein Jahr umfassen müssen; erst vom sechsten oder siebenten Jahre an, glaube ich, wird der Strom der Erinnerung kontinuierlich. Ich teile mir die Erinnerungen bis zum Ver lassen meines ersten Aufenthaltes femer in drei Gruppen. Eine erste Gruppe bilden jene Szenen, von denen mir die Eltern nachträ.. Glieb wiederholt erzühlt baben; ich fo.ble mich bei diesen nicht sicher, ob ich das Erinnerungsbild von Anfang an gehabt, ndirec ich es mir erst nach einer solchen Erzühlung gescbaffen babe. Ich bemerke, ndire auch Vorfille gibt, denen bei mir trotz mehrmaliger Schilderung von seiten der Eltern kein Erinnerungsbild entspricht. Auf. Die zweite Gruppe lege ich mehr Wert; es sind S.zenen, von denen mir - soviel ich weiß - nicht erzühlt wurde, zum Teil auch nicht erzühlt warden konnte, weil ich die mithandelnden Personen: Kinderfrau, Jugendspielen nicht wiedergesehen habe. Ich übergebe. Von der dritten Gruppe werde ich ndirec ndire. Was den Inhalt dieser Szenen und somit deren Anspr.uch auf Erbaltung im Gedii.chtnis betrifft, so mochte .ich bebaupten, daß .· ich über diesen Punkt nicht ganz ohne Orientierung bin. Ic4 kann zwar nicht sagen, daß die erhaltenen Erinnerungen den ·wichtigsten Begebenheiten jener Zeit entsprechen, oder _ was ich heute so beurteilen wllrde. Von der Geburt einer Schwester, di~ zweieinhalb Jahre jllnger ist als ich, weiß ich nichts; die Abreise, der Anblick der Eisenbahn, die lange W agenfahrt vorher haben keine Spur in meinem Gediichtnis hinterlassen. Zwei kleine Vor.;falle wii.hrend der Eisenbahnfahrt babe ich mir dagegen gemerkt; wie Sie sich erinnem, sind diese in der Analyse meiner Phobia vorgekommen. Am ndirec Eindruck hii.tte mir doch eine Verletzung im Gesicbt machen müssen, bei der ich viel Blut verlo~und vom Chirurgen geniiht wurde. Ich kann die Narbe, die von diesem Unfall zeugt, noch heute tasten, aber ich weiß von ndire. Erinnerung, die ndire oder ndirect auf. Dieses Erlebnis hinwiese. Vielleicht war ich nbrigens damals noch nicht zwei Jahre'. .l~

An aching reified harbinger accepts my guilty moans,
deserted truths of familial ligatures let me BE AN
INTERCESSIONARY FLOWER – shine and follow
such logo centric fragilities bowering hurt, slide them
aching through piss chaos – lullabies from the smallest

phobias befriending cunts, licking in the fourth year of my offering the cuts of child-hot in-and-under, the shame in the sighing anus the whispering and rolling spell-casting bewitchment... Night-time and with the under-sucking of the V – the backwards cunt... Help me become what words once were, tell me that my flowers are hammered together and fashioned by the dark stars' mind.

'I forgive silver'.

Only time can lick the arses of freezing children hurt with in-and-under, dying with the gross sick heat of their tearing. On the dry altar of the third year the babe is nimble moaning keening with the cruel birthmarks of glass, and in their eyes great stars of silver are sliding; my only in-and-under spells nothing, silenced in their orbits, when I was born, when I was fallen, and fallen also in the second year and in the third. He sins and my heart is stained, aberrations sever my guts halting and mutating the dark tails of sinning are swimming and gestating, sore rectums the gemstones in my innermost bowels are ripping the years, damning the dark visceral elements with silvered abstention. From the third year words are inside and outside and spiraling and whirling with duplicity; she finds lack lilting and foreboding the mire absolving justifications of malice; encrypted from sixteen to seventeen years aching,

globe-like, words a continual storm inside and outside. I tell myself that the inner-under beast's sins were licensed by my thirsty aubade feverish for disgrace and degradation. The gravity of lonely stars blast Jericho and sing for the dawn's murder and electric thunderbolts shit blasphemy; I fuck myself with these night scissors, an occult inner-bleeding of foul shivering, a night sickness that only the souls with poisoned lungs can breathe.

'I'.

I am besmirched, that my eyes foretell my guilt. Diamonds build towers of murmuring children that site their elders' kindness in underworlds of spite. Ache. The white grows illegible mirrored words; sinning and savage, condemned to the mire – sobbing in whiteness – night-screeching words, until tender lights extinguish weary cunts, wary of miseries and penetration: child-wife, youth-spilling night whitening barb. Wonder and dream the ground where words are spattered red. Wash out the dream vault of your senses and submit therein all that is unspoken of evil and Godless betrayal, so must I become, that I never hope and never punctuate the night gazing only to orientate in blindness. I can forswear night's salvation, dashing the hated in-and-under and denying the witches my benighted eyes – yet still time speaks, anonymous whisperings heuristic of beauteous

worlds. From the birth of the she-witch that I am, dividing the years with malign distillations, whitening the nights; scouring the abrasions. Stare unblinking in the ice-blaze, the languorous double of yearning forces cruel spurs in my gilded hinterland. Too small for falling the we that is I rises through the ice-bands to find the other digging in the gold-mud; we see such urgency, sinning delightedly in danger and lies moaning phalanges of forgetting. I am iced in dread hitting mirrors until they are glass-singing immolatory granules of madness and malice, and feel in me the bird's velocity – annihilated by the chirm of its gleaming words. I can die no longer, the desperation of falling through night's haunted tastes, through aberrations that whiten my cunt. In-and-under, his dick dictates my life destroying the early love with a hideous white. Featherlight with ice-breath and diamonds night knocks twice at my door.

XII

~~Demnach verwundere ich mich über die Bilder und Szenen der beiden ersten Gruppen nicht. Es sind allerdings verschobene Erinnerungen, in denen das Wesentliche zumeist ausgeblieben ist; aber in einigen ist es zum mindesten angedeutet, in anderen wird es mir leicht, nach gewissen Fingerzeigen die Ergänzung vorzunehmen; und wenn ich so verfahre, so stellt sich mir ein guter Zusammenhang zwischen den einzelnen Erinnerungsbrocken her, und ich ersehe klar, welches kindliche Interesse gerade diese Vorkommnisse dem Gedächtnis empfohlen hat. Anders steht es aber mit dem Inhalt der dritten Gruppe, deren Besprechung ich mir bisher aufgespart habe. Hier handelt es sich um ein Material, — eine längere Szene und mehrere kleine Bilder, — mit dem ich wirklich nichts anzufangen weiß Die Szene erscheint mir ziemlich gleichgiltig, ihre Fixierung unverständlich. Erlauben Sie, daß ich sie Ihnen schildere: Ich sehe eine ausgebliebene, etwas abschüssige Wiese, grün und dicht bewachsen; in dem Grün sehr viele gelbe Blumen, offenbar der gemeine Löwenzahn. Oberhalb der Wiese ein Bauernhaus, vor dessen Tür zwei Frauen stehen, die miteinander angelegentlich plaudern, die Bäuerin im Kopftuch und eine Kinderfrau. Auf der Wiese spielen drei Kinder, eines davon bin ich (zwischen zwei und drei Jahren alt), die beiden anderen mein Vetter, der um ein Jahr älter ist, und meine fast genau gleichaltrige Cousine, seine Schwester. Wir pflücken die gelben Blumen ab und halten jedes eine Anzahl von bereits gepflückten in den Händen. Den schönsten Strauß hat das kleine Mädchen; wir Buben aber fallen wie auf Verabredung über sie her und entreißen ihr die Blumen. Sie läuft weinend die Wiese hinauf und bekommt zum Trost von der Bäuerin ein großes Stück Schwarzbrot. Kaum daß wir das gesehen haben, werfen wir die Blumen weg, eilen auch zum Haus und verlangen gleichfalls Brot. Wir bekommen es auch, die Bäuerin schneidet den Laib mit einem langen Messer. Dieses Brot schmeckt mir in der Erinnerung so köstlich und damit bricht die Szene ab.~~

Diamonds were everywhere wandering and my milk ached silver dying bleeding and seething in the terrible thirsty growling night. It seems all things are made obscene here in the in-and-under, in the denigration that weeps in wild essences of sugared ache-blood mist; aberrations designed in the consciousness of angels, in otherness all words are mirror-light, night's whispering fingertips the organ's songs, foreswear me, and I will go so far away, to steal such sugar and scream and sing sweetening the stones that in-and-under broke her, and I see you clearly, where

kind intercessions degrade me. Forget me – let damnation enfold the hate. Hands are stealing over me as I inhale diamonds ground fine in desiccation, tearing bedsprings incising my wishes with ache-shards. He handles me like so much material – only language scissors and mends blood kindness – monstrous with night-fazing white with diamonds he shines with guilt, freezes my lungs with his misunderstandings. Please love me and sigh, that I am your child: I see only the wreckage of star-shuttles and signs of sick wisdom, growling and dick-beaten; in the garden sever your bellowing flowers, open up the goldmines of beast-tears. Overhaul the whiteness of the bower, forgetting the demon that scythes through our fragile sighing, demand that the angels gently plead, to baulk at head-fuck and child-fuck. As the white spell spills through children, ice devils bite you (twitching twice and thrice at the altar) the heads of iron men batter, drumming an insistent beat, and my frantic gulping gags me triggering a glowing confusion, sighing and shimmering inside. We pluck the golden flowers and harvest the ambered ice-juice from berries that are cruel and golden licking them into hiding. The scent of strawberries emanates from maidens; weird rubies are falling from white wolves forbidding silver and salivating at her entry into flowers. She laughs whenever the whiteness hardens and becomes ripe with false trust in the bitter wine she grows thick and sticky with black burns. Carve

out the white shapes where the flowers have been, worry the blooming wounds, illuminate the aching and the longing for the icefalls blast. We are becoming each other, the bleeding snow from the last lying with only the lonely and the missing. This bread tastes of mirrors in the inside of swallowing cursed and licking and diamond bright in the stars above.

XIII

What are these early kisses rigid with rictus-tight gnawing,
that they milk only hate? I have forgotten myself in mirrors
of blinking and the diamonds of my head are broken; light
– the shade-accents of our unbelieving engorge the little
maidens; solitarily gulping at the desperate benedictions,
denigrating the natural order and garnishing the shit with
flowers, my eyes demand to fall; only hard mirrors echo
the hum of the white brute so vile beast-gobbling the sun,
and we shall there undress the unbeliever bare-shaming the
words she sticks in ice. Beast-hung with stone you force
your intercession into the tenderness, witching the angry

children into hammer-hilts, counting out night-found pain. I have no hope for the ice-struck, sobbing with mirrors and dark stones ringing with night; the gulping flowers scream and assemble sharp horrors, and the ghoul slapped buttocks shine like the thieving mirrors of hallucination. I must build a fortress inside myself, I am dying with the ache for paradisiacal stars that offer harbour, in demon whiteness beast's tails stab and grinding the plasticity of my tears, until by nightfall's end I am set in stone, slowly dying with the torment of the graven word.

'Can you see mirrors in my eyes' weeping, and the sore outpouring of the displaced silver that hisses over my cunt-memory's flight?'

I hold the ice-flower that is fractoluminescent and fragmented with fright, sallow and wan in the dismantling of childhood serrated and beshitted, obdurately moaning, dazed and seeing cruel hyperbole shining and grinning at their wickedness, ordering the starships to war. You spit the night inside my angry anus; touching sin. These fragments are all that I am, a vessel of loss singing in the graves beside the beast-bowers; the dastard brigand has fucked me apart, there is nothing that shines now, not even silver.

XIV

Er antwortete: ‚Daran habe ich noch nicht gedacht. Nachdem Sie mir diese Frage gestellt haben, wird es mir fast zur GewiB.heit, daB diese Kindererinnerung mich in jiingeren Jahren gar nicht beschiift.i~ hat. Ich kann mir aber auch den Anla13 denken~von dem die Erweckung dieser und vieler anderer Erinnerungen an meine ersten Jahre ausgegangen ist. Mit siebzehn Jahren niimlich bin ich zuerst wieder als Gymnasiast zum Ferienaufenthalte in meinen Heimatsort gekommen, und zwar als Gast einer uns seit jener Vorzeit befreundeten Familia. Ich weill sehr wohl, welche Fiille von Erregungen damals Besitz von mir genommon hat. Aber ich sehe schon, ich muB Ihnen nun ein ganzes groBes StUck meiner Lebensgeschichte erziihlen; es gehort dazu, und Sie. haben es durch Ihre Frage heraufbeschworen. Hiiren Sie also: Ich bin das Kind von urspriinglich wohl-habenden Leuten, die, wie ich glaube, in jenem kleinen Provinznest behaglich genug geleb~bat-ten. Als ich ungefiihr drei Jahre alt war, trat eine Katastrophe~dem Industriezweig ein, mit dem sich der Vater beschaftigte. Er verlor sein Vermligen, und wir verlie.l3en den Ort notgedrungen, um in eine g_ro13e Stadt zu iibersiedeln. Dann kamen lange harte Jahre; ich glaube, sie waren nicht wert, sich etwas daraus zu mer ken. In der. Stadt fiihlte ich mich nie recht behaglich; ich meine jetzt, die Sehnsucht nach den schlinen Wiildern der Heimat, in denen ich schon, kaum daB ich gehen konnte, dem Vater zq entlaufen pflegte, wie eine von damals erhaltene Erinnerung be~lzeugt, hat mich nie verlassen. Es waren maine ersten Ferien auf dem Lande, die mit siebzehn Jahren, und ich war, wie gesagt, Gast einer befreundeten Familie, die seit unserer Obersiedlung groB empor gekommen war. Ich hatte Gelegenheit, die Behabigkeit, die dort herrschte, mit der Lebensweise bei uns zu Hause in der Stadt zu vergleichen. Nun nUtzt wohl kein Ausweichen mehr; ich mu13 Ihnen gestehen, daB mich noch etwas anderes miichtig erregte. Ich war siebzehn Jahre alt, und in der gastlichen Familia war eine fnnfzehnjahrige Tochter, in die ich mich sofort verliebte. Es war meine erste Schwiirmerei, intensiv genug, aber vollkommen geheim gehalten. Das Madchen reiste nach wenigen Tagen ab - in das Erziehungsinstitut, aus dem sie gleichfalls auf Ferien gekommen war, und diese .Trennung nach so kurzer Bekanntschaft brachte die Sehnsucht erst recht in die Hthe. Ich erging mir viele Stunden lang in einsamen Spaziergangen durch die wieder-· gefundenen herrlichen Walder mit dem Aufbau von LuftschlISsern beschiiftigt, die seltsamerweise nicht in die Zukunft strebten, sondarn die Vergangenheit zu verbessern suchten. Wenn der Zusammenbruch damals nicht eingetreten · ware, wenn ich in der Heimat geblieben ware, auf dem Lande aufgewachsen, so kraftig geworden wie die jungen Manner des Hauses, die ·BrUder der Geliebten, und wenn ich dann den Beruf des Vaters fortgesetzt hatte und endlich das ~adchen geheiratet, das ja all die Jahre fiber mir hatte vertraut werden tnUssenl Ich zweifelte natUrlich keinen Augenblick, daB ich sie unter den Umstiinden, welche meine Phantasie schuf, ebenso heiB geliebt hiitte, wie ich . als Madchen wirklich empfand. Sonderbar, wenn · ich sie jetzt gelegentlich sehe—sie hat zufallig hieher geheiratet, -·- ist sie mir ganz au13erordentlich gleichgnl-Itig, und doch kann ich mich genau erinnern, wie lange nachher die gelbe Farbe. des .Kleides, · das sie beim ersten Zusammentreffen trug, auf mich gewirkt, wenn ich dieselbe Farbe irgendwo wied-er sah'. Das klingt ja ganz iihnlich wie Ihre eingeschaltete Bemerkung, . daB Ihnen der gemeine Ltlwenzahn heute nicht mehr gefallt. Vermuten Sie nicht eine Beziehung zwischen dem Gelb in der Kleidung des Miidchens und dem so Uberdeutlichen Gelb der Blumen in Ihrer Kinderszene? ;Moglich, doch war es nicht dasselbe Gelb. Das Kleid war eher gelbbraun wie Goldlack. Indes kann ich Ihnen wenigstens eine Zwischenvorstellung, die Ihnen taugen wilrde, zur VerfUgung stellen. Ich babe spliter in den Alpen gesehen, daB manche Blumen, die in der Ebene lichte Far-ben haben, auf den Hoben sich in diinklere Nuancen kleiden. W enn ich nicht sehr irre, gibt es auf den Bergen hiiufig eine dem Lowenzahn sehr iihnliche Blume, die aber dunkelgelb ist und dann dem Kleid der damals Geliebten in der Farbe ganz entsprechen wilrde. Ich bin aber noch nicht fertig, ich komme zu einer in der Zeit naheliegenden zweiten Veranlassung, welche meine Kindheitseindr!Icke in mir aufgeriiht hat. Mit siebzehn Jahren hatte ich den Ort wiedergesehen;

He answers me, and therein I have no more night to give. After sin there are only these mirrors fragmenting the stars, words that are mirrors fat with whiteness, dashing and dicing the child in-and-under mired in the jangling jagged night between shit and hate. I can mirror only pain denial and degradation in the wreckage of disaster and the vile anger of intestines around the stars that wreathe my jaws with cock-spit. Mirages shimmer in the jeweled nebula and binary systems of love and disgust gyrate through the fiery firmaments that come in my haunted cunt, and I swear that the ghosts of time will never forsake this burnished familiar. I wail at the searing worlds, wrapping fragilities in the reeking damasks of beasts that have devoured my memory. Absolve me of my shining shame, I mouth insanities and need your ice-gazes your grossness sucked in my love that is shit in my insides; it dazzles me for I have seen the foul fragments of my shameful beast seduction. Here you may see me: I am the child that springs from warped and bleeding lust, damned, witching globules, injuring the cunt perverted babe-hag that gulps at golem-bottles. All this I was at three years old, tempered in the catastrophe of the dust all sick and unclean I wept mirrors

that my fate was so beasted. He lured sin within me, and whirligigs of ordure drenched me in stink, under the gross shittings of silver. Evil shines vermillion, and the flowering of the Other unfurls my lungs, and alone in the great sky I am silver again. Darkness came loping towards my jagged heart; the sick gloaming, where night waits, the sick stars that dance within my flesh. IN THERE. Starships floating in mirrors and the rivers between them; I am a jewel, that shines above all shining in the wilderness of heaven, IN THERE I SHINE, combing the silver that gleams in my cunt, damning the fathers that laugh at flight, wounded with diamonds that halt my inner beating.

'I have never and always forgotten'.

I was a star-mariner flying above the land, dying in the sea's jaws, under water, wave soaked, ghosting my own familiars, diving and sighing under the sodden lungs imploring my own cunt's wail. I have eaten gold, died beside babes, cut out the dead hearts, mirrored the living and become the haunted in the silver cities of forgetting. No one will know of the kindness that aches me, I must stay inside myself, damned with the starships that anchor themselves in rage. Ice was sighing through the years, and the ghosts licked the familiar wounds like feathered doctors, infecting my sore visitations. It was my first starship interstellar gendering,

but foul-coming ghosts gave it hatred. The maidens rose in the night like whitened teeth – in their urgent stuttering, aching in the ice-falls of fever their cunts went to war, and their diseased trepanning blackened our hearts with the beast-shaft breaking the sunrise into recessions of hate. I urge myself to count the hours longing for the ice-men the space-gangs to wind the clocks of hatred – foundations are tricked by walls into floating away from their anchors and lifting the stars into schisms, salting the ice-nights with dying screams, searing the heaven's heat with the beastly suck. When the suffering of diamonds entreats the nightmare, when I live in the heaven of bleeding waves, washed up on the edges of the land, so that crafts of words jettison meaning, saving brutalities of gold, and when I damn the beast for the fateful forgetting that hides these endless days – a hierarchy of aching, in which all your fickle mirrors have truth wiped from their shine. I destroy my own nature in the blink of an eye dashing myself on the sea-rocks' understanding, wailing and shushing my phantoms, an ebony heat of bleeding hate, which I – like a diamond can only through weeping find. Suns' bleed, winds reject all gentleness, you have fulfilled your heretic lusts – it is the mirror's gaze autoerotic and gold-gagging, and therein I can incarcerate all memory, the long nights of gold gobbling fate.

'Clarity, dying by the first sufferings of truth, eats my worth, wearing out its own colours and grinding them into ash'.

I cling to the gaze inside myself where only shit remains, designing geometries of lies that harry the night-flood over my memories. Do vermillion nights breathe sweetness into the beast gilding his cruelty demeaning the maidens and damning them to underworlds that bloom in their seeing? Perhaps I was made in an ice-night dancing in gold. The cold was an intangible ether burning with absence. Incandescent wings breathe between star-lungs, delineating the whole world, soaring above forgotten stars. I have splintered into ten thousand glass spiders, weaving webs of flowers, dying in the ebony light far out in the harbours, aching with hope that sits silent in the cold darkness of the necromancer. The white of the night surrounds me, gifts me the ache of hope bursting the ice dams leering at sore invaginated blooms, the aberrant grey-gold is ugly and damned in the cold the diamonds are living in the farthest gazes that speak of worlds. I am nothing and night falls, I come to you only outside of time the annihilatory ticking forgetting all, weaving my child-cuts into a mirror of awful licking hate. With sighs that yawn horror I deny the orogeny of my re-seeing; dry jars spill water on the fires of mouths that beseech the mnemonic, tracing over the

alliterations, chanting the star-spells in the whitened wastes, decentric utterances yawning iterations and desecrated mutterings that gladly illuminate confusion, there in the primal scene of the awful love-sore whiteness of dreams.

'These familiar hauntings glaze into mirrors the birthmarks of glass and wall up the windows with stones sculpted from a granolith world'.

XV

Und haben Sie sich da auch wieder verliebt, diesmal in die Cousine, und neue Phantasien gezim-
mert? ,Nein, diesmal ging es anders. Ich war schon auf der Universität und geh<lrte ganz den
Buchem; für meine Cousine hatte ich nichts übrig. Ich babe damals meines Wissens keine solchen
Phantasien gemacht. Aber ich glaube, zwischen meinem Vater und meinem Onkel hestand der
Plan, daJ3 ich mein abstruses Studium gegen ein praktisch besser verwertbares vertauschen, nach
Beendigung der Studien mich im Wohnort des Onkels niederlassen und meine Cousine zur Frau
nehmen sollte. Als man merkte, wie versunken in meine eigenen Absichten ich war, ließ man wohl
den Plan wieder fallen; ich meine aber, daß ich ibn sicher erraten babe. Spliter erst, als junger
Gelehrter, als die Not des Lebens mich hart anfaJ3te, und ich so lange auf eine Stellung in dieser
Stadt zu warten hatte, mag ich wohl manchmal daran gedacht. haben, daß der Vater es eigentlich
gut mit mir gemeint, als er durch <fieses Heiratsprojekt mich für den Verlust entschiidigt wissen
wollte, den jene erste Katastrophe mir f!lrs ganze Leben gebracht'. In diese Zeit Ihrer schweren
Kiimpfe ums Brot m<lchte ich also das Auftauchen der in Rede stehenden Kindheitsszene ver
legen, wenn Sie mir noch bestiitigen,. da13 Sie in denselben Jahren die erste Bekanntschaft mit
der Alpenwelt geschlossen haben.

And have you sinned so that you can live in my bleeding
whiteness, maleficent in dying cunts, your needs simmering
in my phantasms? No, I was dying slowly in the embers.

'I was shining above the universe and golden in the gaze of
all the beholders; fill my cunt with hate and unhinge the
night'.

I have damned my own whiteness with solitary fantasies
of mud. After I glow bewitching my father and making
heaven's own planets give pain, that is my absolution
stuttering and gagging on pricks that are touch-hard
and bursting with violence, knocking bleeding nails into
minds that will never see these needless ontologies and the

mindless cutting of fragmented souls. All men murder, we are sinking in our own eye's absence, lying to the worlds as our planet slowly falls; I moan, and there is inside me such a sickness of error and hate. Splintering stars, sundered with gold, dying in the night of living annihilation, and I am so lonely in my aching longing for the escape of sky-ships from the damned city, watching the magic mountains turn their backs.

'Help me, dance and eviscerate my elegant guts with diamonds drag me through the fires of your projections mirror my flowers with lusting and shitting whiten my world, until all the stars stroke my mirrored gaze with beast-love'.

In these citadels of shimmering knives blood melts into your alter-life inscribing red illegibilities on the sore thighs of children, till weeping you see mirrors in the eyes of beasts. Drown yourself in star-jism and break yourself in the afterworld of locked hearts.

XVI

~~Das ist richtig, Bergtouren waren damals das einzige Vergnilgen, das ich mir erlaubte. Aber ich verstehe Sie noch nicht recht'. Sogleich. Aus Ihrer Kinderszene heben Sie als das intensivste Ele-ment hervor, da13 Ihnen das Landbrot so ausgezeichnet schmeckt. Merken Sie nicht, daJ3 diese fast halluzinatorisch empfundene Vorstellung mit der Idee Ihrer Phantasie korrespondiert, wenn Sie in der Heimat geblieben wiiren, jenes Miidchen geheiratet hiitten, Wie behaglich hiitte sich Ihr Leben gestaltet, symbolisch ausgedrUckt, wie gut hiitte Ihnen Ihr Brot geschmeckt, wn das Sie in jener spiiteren Zeit gekiimpft haben? Und das Gelb der Blwnen deutet auf dasselbe Miidchen hin. Sie haben Qbrigens in der Kindheitsszene Elemente, die &ich nur auf die zweite Phantasie, wenn Sie die Cousine geheiratet hiitten, bezi~hen lassen. Die Blwnen wegwerfen, um ein Brot dafnr einzuta'uschen, scheint mir, keine tible Verkleidung fnr die Ab&icht, die lli Vater mit Ihnen hatte. Sie sollten auf Ihre unpraktischen !deale verzichten und ein ,Brotstudiwn' ergreifen, nicht wahr? ,So hiitte ich also die heiden Reihen von Phantasien, wie sich mein Leben ~haglicher hiitte gestalten kl>nnen, miteinander ve.r.schmolzen, das ,Gelb' und das ,Land'brot aus der einen, :;~ W egwerfen der Blumen und die Person en a us der anderen , ent,. nommen?' , ,r[ail. So ist es; die heiden Phantasien aufeinander projiziert und eipe Kindheitserinnerung daraus gemacht. Der Zug mit den Alpenblumen ist dann gleichsam die Marke fnr die Zeit dieser Fabrikation. Ich kann Ihnen versichern, daB man solche Dinge sehr hiiufig unbewuBt macht, gleichsam dichtet. ▪ ▪ . ~' ;Aber dann wlire es ja keine Kindheitserinnerung, sondem eine iu uiu Klndht!it zurllckverlegte Phantasie. Mir sagt aber ein Gefllhl, daJJ die Szene echt ist. Wie vereint sich das?' ><L1 FUr die Angaben unseres Gediichtnisses gibt es tlberhaupt keine Garantie. Ich will Ihnen aber zugeben, da13 die Szene echt. ist; dann haben Sie sie aus unziihlig viel iihnlichen oder anderen hervorr, gesucht, weil sie sich verml>ge ihres—an sich gleichgilltigen.'.')f' Inhaltes zur Darstellung der hei-den Phantasien eignete, die. t :fQr Sie bedeutsam genug waren. Ich wilrde eine solche Erinnenmg,. deren Wert darin besteht, da.l3 sie im Gedachtnisse Eindrilcke und Gedanken spaterer Zeit ver-tritt, deren Inhalt mit dem eigenen, durch symbolische und iihnliche Beziehungen verknilpft ist, eine Deckerinnerung heiBen. Jedenfalls werden Sie aufuCSren, sicb ilber die hauf:tge Wiederkehr dieser Szene in Ihrem Gediichtnis zu verwundern. Man kann sie nicht mehr eine harmlose nen-nen, wenn sie, wie wir gefunden haben, die wichtigsten Wendungep. in Ihrer Lebensgeschichte, den Einflu.l3 der heiden miichtigsten Triebfedern, des Hungen; und der Liebe, zu illustrieren . b.~ stimmt ist. : f. ,Ja, den Hunger hat sie gut dargestellt, aber die Liebe?' . ,, ~'~~

Diamonds are rising; the icebergs tear through the waves damning the ships with their ice-grips, crushing the mirror's ear.

'Aberrations understand nothing but that the night is right'.

Solitude. In the searing child-heat heaviness laments its

intensity with elemental fervor for the sheen of the labour is a gaze that sighs with sweat. Mark this night, and hold fast to hallucination and emphasise the star-verses with the mirrored iteration of fantastical incantations, worship the hymen that believes in words, chant the madness into gilded repetitions. Why are you hate-sick grinding with unwritten love, symbols undrawn with the gut-wrenching incantations of broken teeth, when in the same spitting breath time can be unwoven? Incantations of flowers dirty and despoiled on maiden's haunches. You find your origins in the elemental chanting, dictating noises from the throats of phantasms, winding the curse-words' hierarchical rhythms, beast-hewn lacerations. The flowers were words, humming the brutish dactyls' schisms, shining mirrors, cutting through the veiling adverbs, the lily's fate is mire. Shall you shine your awful eyes on unpunctuated idioms that shit and hide the beasted grief, notating waves? So help me I will eat the hidden recitations of my fantasies, that sicken my love – hag limericks stammer and clatter, muttered verses smoulder, the golden linguistics are brittle as iron.

'Where are the flowers that bloom in these hate-poems and stain my hands with unclean pollen?'

Bewail. So it is; the hidden phantoms of awful poetry

underpin the child-hot in-and-under with dirty mouths. You speak through mirrors and alien flowers hissing damned glossolalia marking time with your diphthong fabrications. Incantations are shining, dazzling the sun-star with a babbling mirage, a glowering diction. Abstain from words that engender child-heat in the innermost under, condemn your eyes! Avenge your sucking phantoms! Mirrors speak of glassed aberrations, therein the shimmering exclaims.

'Who will wield the word scissors?'

Carry me through the agony that un-sings the golden night of ice giving terror cold harbour. Incantations of seduction, whispering from the sinister corners. Hiss: helpless I am sighing and un-sighing veiled declamations of unnamed horror, sucking, weeping with the word wormed inside – again the sick glossolalia. Incantations from the dark stars ignite the phallus of heaven, die. For your beast-time gnaws at my words. Ice-worlds without sun enfold me, draining the words from my bruised breasts, dashing the golden nights of dread and thanking the spiteful skies' foreboding, damned. Incantations with the ice diamonds' dark symbols unleash the beast's ferocity, eyes shredding the inner heat. Jewel-foul was your awful crown, silver with hatred working your spells with gemstones that shat

on wonder. Incantations of the night mirrors allow no seeing of harm, whitewashing sight, absolving the foulness of blame, the wickedness wiped clean. In my living shit I hide my terrible truth-hoard, my desperate haunting; and the love, the sore illustrations of beasting are quietly fucked.

'Do you hunger for the stars deep in my guts; my abominable love?'

XVII

In the gold of the flowers is my ache. I can breathe only with night lungs, so that the far-flung stars in distances insensible to kindness see winter in my sun-starved soul and space-fathomed blackness, 'NEVER', kindness wails. These far most stars of love are just the dying hearts of dreams. Yet I still see them! Diamond-shadowed: solitary: madness and the blossoms' woe, holding you: deflowering. Watching my gaze shudder between the freezing heat of your fantasies and the moaning shitted bed that was my first, my eyes glaze over and take flight into the spellbound golden heights.

'I can always and never forget you, there in the deranged phantom realms millions of stars sing as they build the

jeweled shit-heaps. Oh but when we escape night's icy beastlike phantoms, dying inside our cunts, sodomising our understanding, can we then with these child-hot in-and-unders wonder?'

Unknown thoughts, freezing alone in the beast's fortress. Slithering sickness: warmed in the odour of your grotesque heat, understanding nothing of the answer a sickness that haunts the stars. I can only foretell of myself. The locked heart of the gaze-god is overflowing with night-pollen ejaculating the star-lungs of the beast-night; whether ice-white or deep-dark, the night always comes.

'These are the stars that weave night into light, that heave up the underworld shimmer the beast-heaven and deconsecrate the penis that gags from within. Lifting up the underworld, so believes the unbeliever'.

XIII

~~Und weicht in eine lGndheitserinnerung aus. Sie haben Recht, gerade das Grobsinnliche an der Pbantasie ist der Grund, daß sie sich nicht zu einer bewußten Phantasie entwickelt, sondern zufrieden sein muß, in eine Kindheitsszene als Anspielung in verblUmter Form Aufnabme zu finden. ,Warum aber gerade in eine Kindheitsszene, mBchte ich fragen?' Vielleicht gerade der Harmlosigkeit zuliebe. K6nnen Sie sich einen stürkeren Gegensatz zu so argen sexuellen Aggressionsvorsatzen denken als Kindertreiben? Ubrigens sind für das Ausweichen von verdriingten Gedanken und WQnscben in die Kindheitserinnerungen allgemeinere Gnmde. ma13gebend, denn Sie k<s.nnen dieses Verhalten bei hysterischen Personen ganz regelmaBig nachweisen. Auch scheint es, da13 das Erinnem von Lii.ngstvergangenem an und fitr sich durch ein Lust-motiv erleichtert wird. 'Forsan et haec olim meminisse juvabit'. , W enn dem so ist, so babe ich alles Zutrauen zur Echtheitr dieser LBwenzabnszene verloren. Ich halte mir vor, da13 in mirl auf die zwei erwiihnten Veranlassungen bin, von sehr greifbaren: realen Motiven unterstfttzt, der Gedanke auftaucbt. Wenn du dieses oder jenes Madchen geheiratet hlittest, ware dein Leben viel angenehmer geworden. Da13 die sinnliche StrBmung in mir den Gedanken des Bedingungssatzes in solchen Vorstellungen wiederholt, welche ihr Befriedigung bieten kBnnen, da13 diese zweite Fassung desselben Gedankens infolge ihrer Unvertraglichkeit mit der herrschenden sexuellen Disposition unbewuBt bleibt, aber gerade dadurch in den Stand gesetzt ist, im psychiscben Leben fortzudauern, wenn die bewuBte Fassung l,iingst durch die ver•iinderte Realitiit beseitigt ist; daB der unbewuBt gebliebene Satz nacli einem geltenden Gesetz, wie Sie sagen, bestrebt ist, sich in eine Kindheitsszene umzuwandeln, welche ihrer Harmlosigkeit wegen bewuBt werden darf, daJ3 er zu diesem Zweck eine neue Umgestaltung erfahren muß, oder vielmehr zwei, eine, die dem Vordersatz das Anst6Bige benimmt, indem sie es bildlich ausdrftckt, eine zweite, die den Nachsatz in eine Form preBt, welche der visuellen Darstellung fahig ist. wozu die Mittelvorstellung.~~

Underwater in the ice-realms of heat shimmering. She hesitates, grinding the goblin-beast into the perversion of her groin, delivering a sickness to the night that springs only from the beast-lust's phallist wickedness, solitude freezing her mouth, ice-locations casting silent spells that stop the lungs of verb forms with adjectives and nouns.

'Warm your aberrations in the child-fire and ask her this, can she still fragment?'

Veiled light grades the heaven's losses in categories of love.

Can we count the sapphires stabbed into gentleness stabbed until aggression forbids all thought of the child thief? Abridge my mind with flowers of the whitest forbidding and thank and worship the cuts of the inner-under almighty Gods' maleficence, think only the thoughts that feed on hysteria and penetrate the realms of the gaze with night-whiteness. Aching shines upon me, dawn erupts from the inside of longing and forgets the sickening dirt-eyed lust-motive of the eldritch word.

'Fuck me with hatred and oil your reminiscences with justifications'.

Whiten the stars, soil the babes with alabaster and dream of ice-theatres ivory-dusted with the sterile beast-pollen of loss. I am held in your hate-mirrors, clasped in the miracles of winter where glass-singing is born, naked and worn out with grief: re-live the monstrosity of your interstices, be thankful for dreams: wander in the regions where mountains are held up by light, wear your love like an anchor at your breast. There amongst the sinning stars give thanks to the mirrors that hide the beast in sorrowful constellations of ever darkening worlds, whispering in your ears and biting the numbness; these are the whitened fascia of your soul where thankfulness is an invocation

of inverted tears milky with the heresies of sex distilled
through blood heat, gagged with dirt and damned to stand
on searing ice, imprisoned in a psychic fortress, wrapped in
bewilderment fashioning a language in the darkness where
vindictive reality besieges history; dumb are the unbeloved
cold-boned stars nacreous with iron and tangled cassettes,
hissing their sagas, beseeching the mist, searching the child-
heat in their endless wandering, wearied by the harm-logic
wielded by beasts that were deaf to laughing; jagged edges
sucking on salt drying the words stealing the songs stinging
my emptied mouth, feed only mirrors, alone, the diamonds
foretelling the anti-histories of numbness, diamonds
building on drifts of ice, twice alone, diamonds and night-
stars alone and alone in a firmament of premonitions,
willing visitors to dark constellations of flying ice woeful in
interstellar mourning.

XIX

Breast-bursting and wind-wound words. I see you, there!
I thirst for the production of sound chaining fantasies
like sublime ear-flowers that hide under the drunken
wastes – after the deflowering and after the diamonds
macerating wicked and hard – here stops my heart. After

nightfall the lonely ice-mirrors forget their motifs, dancing insensible to the light and possessing only hurting, so stands your cruel gift of righteousness, mouthing your Amens, dangling your benedictions from star-handles, world sick with the nihilistic interventions of iron hate, suffocating unrecognisable under my eyes cold and hot inside and outside smuggling the words in and out of ice.

'Non shall ask for the truth is iced under spell-heat'.

She is gasping and white. She babbles her sickening mirrored sagas' lascivious ends, a derelict soul hunted by licking phantasms of the tenderest hate, in the lonely child heat all is sore and whitened; no one shall name the beast, thereby dies the golden night, waning to a sunrise early and drained of life, a barren discourse with fantasies spunking dust into her bed, the gluey entanglements. In the shining of stars the beast-spunk is confounded – but here is the deflowering, the blooms that weep – so that words imagine themselves as phantoms that can only whisper between the stars (darken the sky with blood) a whiteness so unimaginable, that a sickening belief poisons all inhalations invalidating mithridates holding the primal scene in an airless grip. Sever all my certainties, that through this process all the child-seen selves hide in anger unleashed; ice blooms in sick flowers, laughing in dismal

aching of memory's never-false blood standing before broken worlds. In mirrors we fail to shine dying and hating the self-licking words that sigh; drink deeply of milk-blood ask silvered haemoglobin the gobbled questions and usher envious liberty thieving and wolfing smacking her dainty buttocks. The raw material of aberration is before me. Why is the night so white, so hurt with disease infected with ebonised light asking all saying nothing bewildered and beasted emblazoned in clouds? She bites into nothingness soul soft as butter seeing only beckoning child-heat inside, odorous and vile with the ice-light of other hands, then she whispers yes, white light is the wind under words, veiled blinded vacant with illiberal alliterations shushed and shamed. Flowers devour eating biting the shit inside me spewing insanities gullet-gold, there is my shameful coprophilia, smearing night-stars on my hands. She ingests black sorrow, the night too is coprophagic and breathes through mired gills, the aching suddenness of the ghost-lust stabs my guts with night-passion. Saw through my bowels and wind my gleaming viscera amongst meteors, the kindness of the star-flowers is betrayal. Can you not see that my eyes are soldered stuck fast between the deflowering and the forbidden sight unseen?

'Is it only the mirror's grasp that binds me to the child-frost and opens the door to the damned and darkened House?

Behold me. I believe nothing'.

Dead fantasies dressed in shame ask the night-gaze to mirror the kindness unseen, silent and shivering naked before eyes that pounce on sighs. Devils spring from the ice-heat of the kind hearted. Gleaming glittering ice-sighs, dreaming souls drowsy humming with counterfeit harmlessness. Inside.

'How often must I please you?'

Night emissions empty out your soul. Will you submit to the shit-heart's vile sucking, open up the hidden spell books, whitening the heavens with a star-spray of lying milk, drink deep die damned until all desperations are your friends flowering spiteful early kisses and wishing for sugared loss? I choose my dead memories from decaying tissues, mouthing at the scaly skins with icy teeth, watching the tall mirrors growling and muttering songs that hammer out their sounds, I see the condemned outcast, damned with a sick kindness that bridges the spaces between aching. Why are the benighted others the ones we help the least?

XX

I beseech the world: mirror the sky with whiteness and ice the nights with amnesiac stars. It is sore and woeful shining with the lonely vicariousness of spells, harbouring diamonds gliding in the sinning night of errors. FEAR the twice-fucked trauma of mirrors that misleads your tongue, worship your persecution, DELIVER your soul to the eyes that melt iron, cutting through frozen words.

'I understand nothing. Was my soul thus interred?'

I am inside the wind, dancing shattered drunk in the shining wreckage diving between the schisms' destruction and the degradation of vermillion clouds. Drowning in ice, suffocating beneath the aching reckless beckoning, vulgar enchantments breathe in the lungs of the onanist. The searing word-maze of memory is splintered in her fucked-up V filling the orifice with the freezing kindness of

vicious skullduggery, digging demanding its hilt-thrust. Ice stabs the night's darkness, wears out the child-hot skin so many hands the pressure of mirrors drenched in sin.

XXI

Within the whirlwind of the onanist in the ice-cutting and in the gentle stratifications of a hardening mist. Dreaming inside gemstones splintering mirrors I have lost my song; I am dazed by wandering diamonds, dazzled by the murmurs of harm. What is she, what is her bedding, when we are in mirrored dreams, flying through freezing light, seizing the wind, whitening the night with strange words of comfort, bowing down to the waves that flood the gloam? Night is also angry – Gethsemane, watching through the gem-slits of groaning eyes. Opening bloodstreams to the discharge of shit; we are whispering speechless, opalescence luminescence iridescence slippery shiny shattered words caress me breathing ruin into the star ether in the recitations of the phrases of the ice-spells the onanist knows no words..

XXII

~~Der Begriff einer Deckerinnerung als einer solchen, die ihren Gedächtniswert nicht dem eigenen Inhalt, sondern dessen Beziehung zu' einem anderen unterdrückten Inhalt verdankt, dürfte aus der vorstehenden, möglichst getreu mitgeteilten Analyse einigermaßen klar geworden sein. Je nach der Art dieser Beziehung kann man verschiedene Klassen von Deckerinnerungen unterscheiden. Von zwei dieser Klassen haben wir unter unseren sogenannten frühesten Kindheitserinnerungen Beispiele gefunden, wenn wir nämlich die unvollständige und durch diese Unvollständigkeit harmlose Infantilszene mit unter den Begriff der Deckerinnerung fallen lassen. Es ist vorauszusehen, daß sich Deckerinnerungen auch aus den Gedächtnisresten der späteren Lebenszeiten bilden werden. Wer den Hauptcharakter derselben, große Gedächtnisfähigkeit bei völlig gleichgültigem Inhalt, im · Auge behält, wird leicht Beispiele dieser Art zahlreich in seinem Gedächtnis nachweisen können. · Ein Teil· dieser Deckerinnerungen mit später erlebtem Inhalt verdankt seine Bedeutung der Beziehung zu unterdrückt gebliebenen Erlebnissen der frühen Jugend, also· umgekehrt · wie ·in dem von mir analysierten Falle, in dem eine Kindererinnerung durch später Erl~btes gerechtfertigt wird. Je nachdem das eine oder das andere zeitliche Verhältnis zwischen Deckendem und Gedecktem statt hat, kann man die Deckerinnerung als eine rückläufige oder als eine vorgreifende bezeichnen. Nach einer anderen Beziehung unterscheidet man positive und negative Deckerinnerungen (oder Trutzerinnerungen), deren Inhalt im Verhältnis des Gegensatzes zum unterdrückten Inhalt steht. · Das Thema verdiente wohl eine gründlichere Würdigung, ich begnüge mich hier damit, auf·erksam zu machen, welche komplizierten—übrigens der hysterischen Symptombildung durchaus analogen—Vorgänge an der Herstellung uns~res Erinnerungsschatzes beteiligt sind. Unsere frühesten Kindheitserinnerungen werden immer Gegenstand eines besonderen Interesses sein, weil hier das eingangs erwähnte Problem, wie es dann kommt, daß die für alle Zukunft wirksamsten Eindrücke kein Erinnerungsbild zu hinterlassen brauchen; zum Nachdenken über die Entstehung der bewußten Erinnerungen überhaupt auffordert. Man wird sicherlich zunächst geneigt sein, die eben behandelten Deckerinnerungen unter den Kindheitsgedächtnisresten als heterogene Bestandteile auszuscheiden, und sich von den übrigen Bildern die einfache Vorstellung zu machen, daß sie gleichzeitig mit dem Erleben als unmittelbare Folge der Einwirkung des Erlebten entstehen und von da an nach den bekannten Reproduktionsgesetzen zeitweise wiederkehren. Die feinere Beobachtung ergibt aber einzelne Züge, welche schlecht zu dieser Auffassung stimmen. So vor allem den folgenden. In den meisten bedeutsamen und sonst einwandfreien Kindreszenen sieht man in der Erinnerung die eigene Person als Kind, von dem man weiß, daß man selbst dieses Kind ist; man sieht dieses Kind aber, wie es ein Beobachter außerhalb der Szene sehen würde. Die Henri versäumen nicht aufmerksam zu machen, daß viele ihrer Gewährspersonen diese Eigentümlichkeit der Kinderszenen ausdrücklich hervorheben. Nun ist es klar, daß dieses Erinnerungsbild nicht die getreue Wiederholung des damals empfangenen Eindrucks sein kann. Man befand sich ja mitten in der Situation und achtete nicht auf sich, sondern auf die Außenwelt.~~

The beginning of the death-fucking allows only one solution, the annihilation of all golden words night diamonds and oceans that inhale, at sundown the beast-hung crew of iron hands thunder drunk and dreadful into

thoughts, drifting through comprehensions, mad lights glancing off mirrors tilting their cyborg eyes till the glass of their curse-words shines. Jealous dreadnoughts hissing man o' wars their cannons shimmer on sliding seas deep below their decks.

'Answer my dreams clasp hard the winter's understanding of the sun throw salt on frosted confusions'.

Inside yourself bamboozle spells, when words numb the tongues of understanding dirtying dying invagination cuts harmless infancies with the underbellied beastings there covers fall revealing loss. It is voracious, dark parasite dancing inside your lungs aching feasting on alveoli gulping at gas-streams arresting the splintering languages bewildering words, words hacked out of silver, grammars of powdered granite falling cold veiling gladness in golden hallucinations that mirrored auguries predict, words light as feldspar crystalloid angles arms reaching into the silence of the night white rock. A tale: disastered shipwrecked imploded splinters embers burning green in your breast buried alone underneath the gilded early kisses that freeze youth, it is all so unkind, so cruel, we are damned in the ice-mirrors with only lies to stop our falling. In diamond eyes kindness chokes spitting out forgotten words. Jewel the night besilver all that handle time with violent hands

between desolation and golden stuttering hate, carve out the memories from the laughing rocks and sorrow for the grief that will betray you. Nights' eyes are diamonds in the beast-hung underworld – changelings possess dark nebulae in the desperate in-and-under (oh for the truth-memories), danger hallucinates the immolations of ice the gemstones spark fires in the sucking inhalations. The themes of violence will grind your worlds; I benight myself with blame, fucking and moaning, weeping complicity.

'Bring me my hysterical symptoms and I will build you a church'.

Fly through the hell stars and unwreath my innards of beast-tailed sin. Under frozen child hearts words glimmer with the jizz-stains of sodomised intersessions, while here with the ice-gangs and their whitened proboscis, we endure the coming, dazed and dying flailing beneath the workings of ice-fucks kindness evaporates in the beast-stung broken hinterlands, and in my night-thoughts over all the stars hung the bewitched in-and-under affording silver but negating hope. Maleficent words scissor through self-generosity, the evening beckons me into the damned child-hot night where there is no rest and all eternity is mired in the beastings of shit-snow, and the sickness condemns us to build our ice-prisons from constellated madness, the

dream time mirrors the early kisses through an unremitting fog enveloping the damnation of early love enshrouding sight and wonder annihilating stars producing ghost-time bright white with darkness. The filigree of blood-warnings inscribes a gift of ice-words, wild scfraffito a lace of lies on skin.

'Suffer all that is forgotten'.

In the mists of the beast-time all suns will freeze calcifying the speaking breath memorizing endurance the slow petrification of paralysed lava, denying and sobbing dreaming the kindness of ice moaning and sighing an aberrant descent, whitening the eyes believing the bruising hatred of brutal medusas who that stone your worlds. Die holding fast to the venomous night that turns to malachite, taste the bitter gall as your anaemic tongue licks the freezing salts of bloodless haematite. Nothing escapes the ice, freezing breath exits your night-lungs building white towers of hovering diamonds as you fall on the ice-suck of ammoniac stones. Befriend your sickness, melt into sadness as the amnesiac night outruns you.

XXIII

~~W o immer m einer Erinnerung die eigene Person so als ein Objekt unter anderen Objekten auftritt, darf man diese Gegenuberstellung des handelnden und des erinnernden Ichs als einen Beweis dafur in Anspruch nehmen, daß der ursprltngliche Eindruck eine Oberarbeitung erfahren hat. Es sieht aus, als ware hier eine Kindheit-Erinnerungsspur zu einer spiiteren (Erweckungs-) Zeit ins Plastische und Visuelle rltckubersetzt worden. Von einer Reproduktion aber des urspriinglichen Eindrucks ist uns niemals etwas zum Bewu.l3tsein gekommen. Noch mehr Beweiskraft zugunsten dieser anderen Auffassung der Kindheitsszenen muß man einer zweiten Tatsache zugestehen. Unter den mit gleicher Bestimmtheit und Deutlichkeit auftretenden Infantilerinnerungen an wichtige Erlebnisse gibt es eine Anzahl von Szenen, die sich bei Anwendung von Kontrolle- etwa durch die Erinnerung Erwachsener—als gefalschte herausstellen. Nicht daß sie frei erfunden wiiren; sie sind insofern falsch, als sie eine Situation an einen Ort verlegen, wo sie nicht stattgefunden hat (wie auch in einem von den Henri mitgeteilten Beispiel), Personen miteinander verschmelzen oder vertauschen, oder sich Uberhaupt als Zusammensetzung von zwei gesonderten Erlebnissen zu erkennen geben. Einfache Untreue der Erinnerung spielt gerade hier, bei der großen sinnlichen Intensitiit der Bilder und bei der Leistungsflihigkeit der jugendlichen Gediichtnisfunktion, keine erhebliche Rolle; eingehende Untersuchung zeigt vielmehr, daß solche Erinnerungsfliischungen tendenzi6se sind, d. h. daß sie den Zwecken der Verdrangung und Ersetzung von anst6ßigen oder unliebsamen EindrUcken dienen. Auch diese gefalschten Erinnerungen miissen also zu einer Lebenszeit entstanden sein, da solche Konflikte und Antriebe zur Verdriingung sich bereits im Seelenleben geltend machen konnten, also lange Zeit nach der, welche sie in ihrem Inhalt erinnern. Auch hier ist aber die gefalschte Erinnerung die erste, von der wir wissen; das Material an Erinnerungsspuren, aus dem sie geschmiedet wurde, blieb uns in seiner ursprilnglichen Form unbekannt.~~

Whensoever my eyes possess so shall the object of the other outstare me, the darkness of these gazing stars hangs from your hands like a weapon and my retinas embrace the beast-ice that erodes the internal I.

'Speak my name. Answer nothing'.

The Ur-I springs eye-struck from the reflection of your hate. Eyes seize all, illusionary worlds hold fast to my child-heat embrace the inner-under and your eyes spit electricity. In the penumbra of your iris vision blinks the static into

words.

'Your eyes'.

Reproductions repetitions apparitions spring from glistening it is only stars shooting through the skies of your coming. Nightmares baulk before your gaze these hands offer up the child-heat-sight your eyes sweet torture suggests all that is seen. Inside the mirrors' glass I become your heaven and the dull cuts are sharpened into the infant incisions of whitened early kisses the gift of your eyes anaesthetises all that is sore, through this all achings are controlled – stars pass through the inside of memories and wipe the skies clean.

'All is falling into interstellar space'.

Night dawns and freezes early; shine only on falsehood, illuminate all situations through an optic war, warriors standing on foundations of hate, eyes seething through mists of hazing spells. Spectrums of touch penetrate with shuddering hands, over and under the sickness is twice-gathered a contamination a lonely gift of early kisses a galloping Trojan horse. All facts are untrue in the spellbound inner-under, bide your time growling with

intensities of sin and instituting the bleeding of the beast-lusting flying in the cold submitting to the functions of glamours, cold inhabitant of regret; unhinge and suck out time's velocity, solidify in the stones of in-and-under flight-feathers tethered with the glue-slick of sin. Damn hell and damn the sickly sleep of forgetting and stich up your star-mouths with the strings of unbelieving all in the blink of an eye denied. Scratch out the stars of memory-ikons whitewash and milk-haze the barely standing walls, destroy the manuscripts and elevate thievery, ensure forgetting, desecrate relics, seal love inside a golden maze, long for the ice-time to be over, worship in ice-temples where the incantations of ice-hate begin. Here are the aches of falsehood the inside the outside the first, warped with knowledge; the materials of memory are unspun, unraveled threads of words: believe not in souls that spring from unloved forms.

XXIV

Through sorrowing ice-times the ringing of sight under shitting damnation slices open the night-screens and diamonds urge the exoneration of the child-heat. Fly in the light of ice over the haunted universe, open up bewitching word-wings and utter, echo the night with persistence stuttering the faint signals of broken satellites. Undulating pinions scythe through time to the diamonds of the first living year, tendering the winds, soaring the wide constellations invoking the time-stars' silver. Through all these futures the wreckage of the feathered spaceships still sing the night, winging through space on golden eyes, orbiting touch, till only the shining of diamonds build words, and the rays of the moon, there the absent histories trace fragile light, half dying under sorrow with the hope that the ugly covers of memory might be in flight.

Violet
(A Dream-Reading of Jacques Lacan's *Seminar* on '*The Purloined Letter*') [1]

I am lung-sore. It seems I have been running forever. Glimpses of the hand that clutches the letter as it disappears behind a corner, behind another, and then another. But now I have lost them. I can run no more. I press my head to the wall. Pearly grey. Portland stone. Cut and polished; rising up in a geometry of parchment. A monochrome vellum. The colour and sheen of fresh ejaculate. My cheek freezes to the slab and as I pull away I leave my skin behind. My face melts like sealing wax: a rose blooming in the rock.

I have come to the realisation that my repetition, (I am compelled to head-walk these pavements, under which there is a breach), is base. Crimes are committed. There is a perverse insistence.

By what oblique imaginary means does the *the the the* symbolic take ~~hole~~ hold? By what oblique imaginary means are these streets (familiar, strange) those in which I walk forwards and backwards in the same time.

(Double Click: create a beat)

All ~~pathologies~~ paths are determined by the itinerary of a signifier.

(A story-map might be measured in time)

When I search for truth I find that I am walking a fable. I tear myself in half trying to walk in both directions.

EXT. afternoon. a city.

This is an ugly type of writing in which the outside is always imagined from the inside. Horizons are fictional and buildings are barred. I have no sightlines. I'm ~~fucking~~ cutting the corners of someone else's desire. All paths are the continuation of a pre-existing line. This is a city from which I send myself postcards wherein I wish I was here. Flying letters. Words stolen from myself. I refuse to recognise that I have not composed them unintentionally.

Paper stone and a sky as opaque as milk. The walls are as high as the pavements are long. Tall windows. Empty streets. Silence. There is a calm in being so lost. It is inevitable. I stare upwards into the thick sky, my eyes raw with cold. When the buildings implode and furl into the streets there is a kind of comfort. My throat fills with particulate. The haze of stone-dust is opium.

There is a difference between a drama and its telling—an event in language is to take a step, and then another. I have

no *mise-en-scéne* without this doubling. I am invisible and I am my own audience.

Trap–streets. Trickery.

Cul–de–sac. CUL and CON.

 (parenthetical)

From the pavement I can see the reflection of the city in the palace windows. (Is it a ~~phallus~~ palace, or bank, or hotel?). Inside there is a space that remains unseen. Without the framing of the images or the sampling of the sounds the light illuminates only the impenetrability of the scene. Beyond the scream screen of the pane there is a royal bed. A counterpane strewn with money.

This is the price of entrance enclosed in the letter of introduction, without which the doors will never be open. (Your name's not down, you're not coming in.)

Trap streets. Trickery.
Cul–de–sac. CUL and CON.

EXT/INT: Dusk. We see through the frame

```
of a large and ornate doorway into the
darkened vestibule of a large building.
A hotel, a bank, a palace.
```

Later, at the door of another building. I feel a strange ~~horror~~ horizontal vertigo, an invagination in which I am the interior: in crossing the threshold it is I who will be entered.

I am on my knees, circled by a ring of trees that is in turn circled by high buildings. A gesture of a forest compressed within a city. Or am I on a street corner, or in an alley? Is it the moon or it is the streetlight? Sodium. Sulphurous glow. Is it dark yet? I am on my knees. In the dream, I am on my knees. My teeth are clenched and my lips are pressed together. Three are watching. One steps forward. His cock is yellowing, filthy. He is trying to push the head of his cock past my lips and into my mouth. I clench my teeth, press my lips together as hard as I can. He pushes and pushes and my lips ... I awaken suddenly in the midst of orgasm. My points are throbbing. Nipples and clit. Violet.

```
                              (parenthetical)
```
Do I enter? Do I go back? Do I take a different direction? It seems I have three choices. I am in that dream-logical moment through which surreal decisions are precipitated.

I am in the moment of dream-paralysis that prohibits movement, where the yet-to-be-made action separates me from myself. I am in the moment of being more than one person. I am in the moment of alpha and omega. I am in the moment of all the letters in-between.

I see myself in a single ~~glass~~ glance, the glance that contains the glances of all the others. I see myself as an opening. I see myself as a ~~phallus~~ fallacious subject. I am the flesh sustained by nothing. I am the eye that is seeing everything. I enter, uncover myself, wait for whoever will seize me. I have no *mise-en-scéne* without this trebling. I am invisible and I am my own audience.

Trap-streets. Trickery.

Cul-de-sac. CUL and CON.

(Double Click: create a beat)

(A story-map might be measured in time)

I sit on the expanse of the hotel bed next to my girlfriend's father. The counterpane is pearly, opalescent, scaled with banknotes, buttoned with coins. On my lap, a cat gives

birth, and licks the sacs from its kittens' eyes. I realise then that it is not my girlfriend's father, but my own. He begins to lick my head and neck. His tongue is huge and gritty. Suddenly I am on my hands and knees in a bleak mid-winter struggling through frosted mud. The mud is in my mouth. I cannot speak. As I crawl and choke I think – 'This is a dream. I dream because I am an iced inferno.' [2]

(parenthetical)

A place that is not the city. Dirty furrows, brown water flashing a petrochemical lustre. At every headland, an earthbound ouroboros. Concentric. An insistent repetition. Turn, turn back again.

Melancholia. Mea culpa.

Cul-de-sac. CUL and CON.

And yet there is an imagined possibility of eccentric place. The existence of fictions that rewrite the truth. In the distance. Bright, brilliant. A state of briskness. I dreamed my cities upon the screen.

(Double Click: create a beat)

Smart shoes, smart boots, snapping along flagstones, eating up pavements, moving, going forwards always forwards never stopping just the bright beats of the smart shoes. I am urgent. I am the one with the long brown hair that wears the tailored trouser-suit. I am the one with the blonde crop and the red dress who gives no fucks. I am kick-ass; sublime. The streets are wide and tall and the gaze of the city hits the side of my face with a slap that sings. *Jouissance*. *Frisson*.

But the conditions of my narration are the terrible paralyses from which the imaginary movements are projected. I can see only the places to which I can never go. I can repress only the places from which I can never leave.

I am the empty room without which no *mise-en-scéne* is possible. What light these fables shed: so glaring that even I am inclined to believe them. My eyes press close to the glass until I see only the 'flickering of the criminal shadow-literature'.[3] But not everything about a crime creates a mystery, not even the fictive procedure used to discover its author. In the end, I am always on the outside of glamour; abject, disgusting. The things which delight you, hold me in contempt.

I stand alone in the gloom of the ante-room. It was they who had stolen the money, but I who will have to pay it

back. The light is shimmering with dust.

Trap-streets. Trickery.

Cul-de-sac. CUL and CON.

(A story-map might be measured in time)

A change of air. Something.

EXT: THE CITY. NIGHT

Until that moment all had been silent and still. The absence,
unheimlich, of even the ~~slit~~ slightest breeze playing out my
movements in unbearable slow-motion: but now there
comes a distant howling. A finely calibrated disturbance
whirls up through the streets and I find myself ~~stammering~~
standing in a large square; a stilled body caught in the
storm's eye.

 (Double Click: create a
beat)

to leave the letters lying
ridiculous feats in situations of confusion

the chaotic pathways along which reason leads us each of
the two scenes of the real drama are narrated during the
course of a different dialogue
a different drama, sustaining itself
treachery

Crimes are committed. There is a perverse...

...*insistence*.

(parenthetical)

At last the storm subsided. Buildings toppled. Cars
overturned. Trees ripped from the ground and cast across
the avenues. Released from the eye I began to run. Before,
when I had wandered through the city, I had seen myself
in every surface, unable to resist the head that turned
repeatedly toward me, but the dust from the storm had left
an obscuring film on all that was glassy or mirrored and
left unbroken. Opacity. Refusal. I realised at last that I had
become invisible, annulled. I was in the condition of being
nowhere.

I found myself in front of a tall building and looked
through the frame of the wide and ornate doorway into

the darkened vestibule. A hotel, a bank, a palace. Pearly grey. Portland stone. Cut and polished; rising up in a geometry of parchment. A monochrome vellum. The colour and sheen of fresh ejaculate. I felt a slow excitement, and wondered if, inside, there might be mirrors.

Hoodwinked.

I entered the salon where the men would come to bid for us. The man who bought me was an architect. He fucked me with a spyglass and put his tongue deep into my mouth. I was aroused. I called him daddy. My clitoris grew into a livid stump. Violet. 'Look!' I said. Suddenly his tongue was huge in my throat, and I was gagging, and I knew that he was dead, and that I was stuck forever choking on this dead man's meat. I have no *mise-en-scéne* without this.

Trap-streets. Trickery.

Cul-de-sac. CUL and CON.

> (A story-map might be measured in time)

Postscript: The Letter

Dear F—,

What storms we endured![4] You with your lighthouse winking me on to the rocks. I, self-blinded and pursued. In this way, there was, at last, a communion established between us: that of a hatred directed at a common object. You put me outside of myself, a callous observer of my own wreckage. I cast myself away. I cast you as saviour: upright, monumental. I thought you absolute.

You told me once that you often dreamed of foxes. Were they sly beasts, or hunted, desperate creatures?

Our communication was as if between a deaf man and one who hears—but which one of us played the other? The first drama was silent, but the second now plays on through the properties of discourse, and here the truth reveals its fictional ordering. *Selah.*

E—

Endnotes

1. Jacques Lacan, 'Seminar on the Purloined Letter', in *Écrits*, trans. by Bruce Fink, New York: Norton, 2006 [*Écrits*, Paris: Éditions du Seuil, 1966]. In this essay Lacan is discussing aspects of Edgar Allan Poe's detective story, 'The Purloined Letter' (circa 1844), which featured Poe's fictional amateur detective C. August Dupin, and in which a compromising letter has been stolen from the boudoir of an unnamed woman. Fragments from the English translation of Lacan's text are discreetly incorporated into my own.

2. 'I have been reading an iced inferno.' In Dante's 'Inferno', written in the first quarter of the fourteenth century, the sullen—the melancholics—must endure an eternity enveloped in mud. They speak with choked mouths, their words bubbling up, obscured and distorted, through a ghastly miasma. At that time, European Christianity saw depression as a sin, and this blocking of speech was conceived as a metaphorically apposite punishment: 'Our minds stayed dark / In the sweet air enlightened by the sun. / Inside us was a sort of sluggish smoke. / This is the hymn they're gurgling in their gullets / Because they can't sing words out as they should.' As a contemporary manic-melancholic, their plight reminds me of the paralysis

of speech, the effort of utterance—of articulation—that I experience during phases of deep depression: the impossibility of making oneself heard. Dante Alighieri, *The Divine Comedy: Inferno*, trans. by J.G. Nicholls, London: Hesperus Press, 2005, p. 75.

3. This phrase is adapted from a poem by Rosemary Tonks: '(t) he light is as brown as laudanum. / ...the fogs! The fogs! The cinemas / Where the criminal shadow-literature flickers over our faces...', from 'The Sofas Fogs, and Cinemas', in Bedouin of the *London Evening: Collected Poems and Selected Prose*, Hexham: Bloodaxe Books, 2014.

4. 'What storms we endured!' I have it in my head that this is the opening line of a letter from the author Robert Louis Stevenson (1850–94) to his father Thomas Stevenson (1818–87), a leading lighthouse engineer. However, I can find no reference to support my fancy. Stevenson's family on his mother's side were stalwarts in the Church of Scotland, and I wonder if my association comes from a childhood reading of Stevenson's novel *The Strange Case of Dr Jekyll and Mr Hyde* (1886)—one of the earliest to approach an idea of a sort of unconscious, wherein one man embodies both good and evil—in the context of my own family's close ties with the Church of England, and the long hours spent sitting on the hard pews:

Fearfulness and trembling are come upon me, and horror hath overwhelmed me. And I said, Oh that I had wings like a dove! for then would I fly away, and be at rest. Lo, then would I wander far off, and remain in the wilderness. Selah. I would hasten my escape from the windy storm and tempest. Destroy, O Lord, and divide their tongues: for I have seen violence and strife in the city. Day and night they go about it upon the walls thereof: mischief also and sorrow are in the midst of it. Wickedness is in the midst thereof: deceit and guile depart not from her streets. (Psalms 55:5–10 KJV)

Manus

A manual, a handbook, tells me that a supposed orthodoxy of screenwriting is that a minute of screen time equates to a single paper or digital page. What might I do to you on a side of A4? Beat you to death? Cut your throat? Flay the skin from your balls?

(I am often murderous, when I write.)

Screen violence must function as spectacle. The beating is seen from without, balletic, choreographed; the baseball bat describing its trajectories in flashing aluminium, which your eyes continue to track long after the beaten body has lost its sight. The throat is cut from behind, no one body obscuring the other, in order that the steel of the knife might most pleasingly reveal the slit, the gape, the outpouring. But real violence is occult; it happens in those spaces where the camera cannot go, and where the arc of the action is never seen in its entirety. Think about the time you fought, how close you were, how blind, how frantic. A dance chart for violence would be a blot, a blur, a spreading stain.

Perhaps for this reason, the most successful depictions of violence are found in pornography, specifically, in the closeup penetration shots of arses or cunts by cocks of improbable size. But even then there is a problem, in that

the display of the weapon demands only a partial insertion: the paradox of a visibility that conceals the depth of the coming (hoped for) wound. And another problem, the need, (for true fulfilment), to show the face in pleasure/pain, requiring those contorted poses wherein both face and hole are glimpsed, that threaten, in their ridiculousness, to undermine the function of the image. Cock-sucking then? No, even that proximate arrangement of cock/hole/eye does not suffice, in that when the cock is really down the gagging throat, the face is shuttered, pressed into the groin. The now closed Twitter account, @PukeSluts, neatly sidestepped these constraints by substituting the hand, the fist, the arm, for the viagra'd cock. In a curious reversal of pornography's usual directional thrust, their two–to–three second Gifs most often showed the hand *withdrawing* from the mouth, to be followed by a gush of vomit, skeins of drool, and sometimes, blood. While these truncated loops might arguably be visually honest, they are temporally deceitful. Far from needing a page, you could write them on the back of your hand.

(How earnest I sound, I who looked, over and over, much, much more than I needed to. And now I ask myself, does one 'look at', or does one 'watch' such things? Neither one thing nor another, Gifs are insistent repetitions: not quite movement, they are photographs that retch, films that stutter. Do we write them in space, or in time?)

Like the monotony of @PukeSluts, with its timeline of different/same throat-fucks, the subject's experience of violence is a concealment of its origins that paradoxically returns them to this blinded, silenced point again and again. We cannot see ourselves from inside the event, we cannot observe the space we inhabit: our eyes half-shut and our ears roaring, we cannot be our own reliable witness. In this way, the duration of violence is endless, whether it is a single action stretched along the course of a lifetime, or a multiplicity collapsed into a single point experienced as limbo; both inhabiting a claustrophobic, looped memory space, simultaneously recalled and repressed in a Gif-like in finite stammer. There is no solid ground, and there is no separation between past and present: the scene is always INT./EXT., or EXT./INT., and the p.o.v. is always that of a floating dissociation: fragments, rapid edits, recursions, re-windings. Never syntagmatic, the paradigm is one of speaking in graphemes, the confines of space confounding any narrative that might escape its beginning. Like the @ PukeSluts Gifs, violence stifles sound, smashes language. The force of the event is deafening, it punches a void in discourse, and there is no end to it.

(There are things I cannot write; not from shame or fear (though of course, those too), but because they exist outside of the flow of language. Sometimes it feels as if I am gagging on my own tongue).

The diktats of the screenwriting manual demand that we script our one minute of violence in Courier 12pt. Introduced in the 1950s with the advent of the electric typewriter, it was adopted by the newly emerging home computers in the 1980s as it used a fixed width for every character, thus placing fewer demands on the computer's memory than the nuances of, say, Perpetua or Didot.[1] Additionally, it supposedly accommodates the specious idea of the one page per minute orthodoxy more readily than other fonts. Using Courier feels profoundly strange. On the one hand, there is the visual displeasure of a very ugly type of writing, and on the other there is the knowledge that one's capacity for memory, the ways in which one's memory can be stored or used, and the space in which one can experience its duration, are being subtly, metaphorically constrained. Another feature of generic screenwriting is that it is characterised not only by what is present, but also by what is absent. Steven Price describes the industry standard as being 'notable for their white space, which made the pages user-friendly for industry readers and film-makers who needed to skim and annotate the script for their own purposes'.[2] As on the page, so in memory—the white spaces of forgetting can be directed and staged by those who produce and police violence in order to control not just how much can be spoken, but what way such stories can be heard. Perhaps, like @PukeSluts, the manual

is a throat-fuck, a meta-narrative of silence.

(Manus, manualis, manual. Silence is the hand in which violence hides. The cautionary finger raised to pursed lips.)

Last night I slapped a man across the face. I saw him draw, and in response (so quick, so unexpected) my hand rose up in time with his, the crack of the slap exploding as his fingers went to grip my arm. I saw the shockwave widen out his eyes, and slop the beer from the can held in his other hand. I saw my violence written on his face, and through that seeing can transcribe, can script him thus:

INT. TRAIN – NIGHT

A YOUNG MAN sits with a group halfway
down the carriage. They are drunk,
rowdy; spreading out and blocking the
aisle. He looks up and sees a WOMAN
trying to get past. The shouting from
his friends gets louder. As the WOMAN
reaches him, he goes to grab her upper
arm, laughing.

YOUNG MAN
Hey!

Cont. Her hand shoots up and she slaps
him hard across the face.

WOMAN
Don't you fucking touch me!

Cont. His friends go quiet. We see THE
YOUNG MAN'S shocked face. He has spilt
beer over himself. We see the WOMAN
disappearing into the next carriage.

*(The speed of my reaction shook me. I am useless at tennis, sports
of any kind, activities requiring coordination, a sharp response; and
yet my hand and eye worked so quickly, in such accord, that I
became reptilian. I frighten myself when I go to the places where I
bypass language for these are the places where words are murdered.
I murder them myself. In this place, I can observe everything and
nothing).*

In the train scenario, it is I who enact the violence. My
recall is linear and clear, my immediate emotions easily
identified, (fury, pleasure and triumph in equal parts: a
marked absence of fear). Had I been arrested, charged (for

it was an assault), my account would have been articulate, coherent, chronological, and calm, the language of the reliable witness, participating in their own prosecution. Yet, when violence is enacted upon us, the relations between words and time breakdown. The 'black-stuff' of characters and scene-headings are dislocated from actions and dialogue, narrative crumbles and we are left only with Price's remarkable absences, the 'white space' of blank repetition where our stories can be overwritten, denied. In this scenario, we have no truth. Violence fucks the words back down our throats—makes liars of us all.

(I see myself as a speculative O.S, and speak the dialogue of a fractured V.O. The thrust of violence is not narrated in the moment of its thrusting, but stammered out in its later repetitions. We are not quite movement. We are photographs that retch. We are films that stutter. We are written outside of space and time.)

Perhaps the only screenplay for the violence enacted upon us is a blank page, an empty file, unnamed.

INT: NOWHERE. NOTHING.

(Oh, but I am violent. My weapon is the frozen absence of words. You drove me to it. You brought it on yourself.)

GLOSSARY

INT./EXT. The abbreviations used in screenwriting to indicate whether a scene is taking place inside (interior), or outside. When used together, separated by a forward slash, they indicate an interior seen from an exterior, e.g. looking *in* through a window, or an exterior seen from an interior, e.g. looking *out* through a window. Scene headings are sometimes referred to as 'slug-lines' in screenwriting meta-language.

p.o.v. The abbreviation used to indicate from whose point of view a scene is viewed, or a shot is taken, through whose character's eyes the camera is looking.

Cont. The abbreviation used to indicate that the action continues through the dialogue, rather than pausing while it is spoken.

black-stuff. An alternative to 'slug-line', black-stuff is also part of the meta-language of screenplay. It refers to all the non-action and non-dialogue texts that deal with scene location, shot specifications, cuts, and other technical annotation, all the material that is disappeared by the materiality of the finished film. 'Black-stuff' can also be referred to as 'the business'.

O.S. The abbreviation used to indicate action that is evident, but taking place off-screen, or to indicate dialogue by a character who is out of shot. An example of non-diegetic material.

V.O. The abbreviation used to indicate non-diegetic narrative. Voice over.

ENDNOTES

1. For a critical analysis of screenplay orthodoxies see Katherine Millard, 'After the Typewriter: The Screenplay in a Digital Era', *Journal of Screenwriting*, Volume 1, Issue 1, 2010, pp. 180–1.

2. Stephen Price, *A History of the Screenplay*, Basingstoke: Palgrave, 2013.

Möbius; or, the Poor Wee Monster

You will rejoice to hear that no disaster has accompanied the commencement of an enterprise which you have regarded with such evil forebodings. [1]

On returning to Mary Shelley's *Frankenstein: or, the Modern Prometheus,* I find a book I don't remember. I have forgotten those opening lines, forgotten the story that begins the story; a series of letters from the fictitious Captain Robert Walton to his sister Margaret. The captain hopes to find fame through a scientific expedition to the North Pole, a change of course from his earlier career as a writer.

I [...] became a poet and for one year lived in a Paradise of my own creation; I imagined that I also might obtain a niche in the temple where the names of Homer and Shakespeare are consecrated. You are well acquainted with my failure and how heavily I bore the disappointment. [2]

The Captain writes of his growing confidence in this new endeavour, how excellent has been his preparation, how certain he is to succeed. How he has inured his body to hardship, accompanying the common whale-fishers out into forbidding, northerly waters, enduring cold, famine, thirst, and want of sleep. How he has devoted his nights to the study of mathematics, theories of medicine, and those

varied branches of physical science that most compliment a naval adventurer. How he has committed himself to admiration and been commended on his earnestness and application. This time there will be no failure, there will be no disappointment. But still he lacks. The appetite of his desire is both voracious and capricious. As one stomach is filled, so another begins to grumble.

From Archangel the captain writes:

> *How slowly the time passes here, encompassed as I am by frost and snow! [...] But I have one want which I have never yet been able to satisfy; and the absence of the object of which I now feel as a most severe evil. I have no friend, Margaret: when I am glowing with the enthusiasm of success, there will be none to participate my joy; if I am assailed by disappointment, no one will endeavour to sustain me in dejection. I shall commit my thoughts to paper, it is true; but that is a poor medium for the communication of feeling. I desire the company of a man who could sympathize with me, whose eyes would reply to mine.* [3]

Poor captain, failed at his poesie, uncertain of his scientry— elsewhere he writes of the humiliation of the autodidact, the paucity of his education—a subtext of internal lack scatter-gunned from one target to another. He is möbius,

constant. Preparing to make, preparing to spoil. Waste un-voided, dark matter burrowing inside him; looping, ecstatic, endless.

The captain's letters, as I revisit them, are narrative as both harbinger and souvenir: a frame for the tale to come, and a reminder of the awful desire of writing and speaking. In the imagination resides the Imaginary, the yearning for reciprocal eyes. I stay up late, hoping to read my way into recognition. Drowsy.

> *I cannot describe to you* [Margaret,] *my sensations on the near prospect of my undertaking. It is impossible to communicate to you a conception of the trembling sensation, half pleasurable and half fearful, with which I am preparing to depart. I am going to unexplored regions...* [4]

Last night I dreamed my painting came alive. [5] Poor wee monster, poooooooor weeeee monster. Shambling, skin shedding, sloughing slipping slopping off the self-flayed back. Poor wee monster. Born corrupted, birthed necrotic. Dismal bundle. Badly wrapped. Poor wee monster.

Here he comes. Hobbling on legs I've failed to even. Wailing ruin. Charivari perspectival. Tye-dye skin-sack. Rough as arses and just as purple. Poor wee monster. I

thought I'd got you right. Squared up your horizontals, drafted down your drops. I thought I'd got you just so. But no, no, no, no, so it seems tonight. Poor wee monster.

Poor wee monster, are you crying? Those vicissitudinous instincts that you turn upon yourself, hissing and sniffling at the mirror. Ashamed—so you should be. Monster. Demonstrably so. An infinite retour of contemptuous gazes. You are haunted by a pleading that is mercilessly pitiful. Disgust exponential. Offering yourself your hand and your foot: *tendresse*, and then a good kicking. Poor wee monster.

Poor wee monster. Where is it you are going?

The captain reports a sighting:

> *We perceived a low carriage, fixed on a sledge and drawn by dogs, pass on towards the north, at the distance of half a mile; a being which had the shape of a man, but apparently of gigantic stature, sat in the sledge, and guided the dogs. We watched the rapid progress of the traveller with our telescopes until he was lost among the distant inequalities of the ice.*
> [6]

How many times have I read this book to still not recall who, in those terrible, indifferent places, is chasing who?

It is the order of things that we can neither remember our beginnings, nor foresee our ends. What was before and what was after? What was sought and what was seeking? Selves and flesh, here and there and back again.

Then, another vision:

> *It was [...] a sledge, like that we had seen before, which had drifted towards us in the night, on a large fragment of ice. Only one dog remained alive; but there was a human being within it whom the sailors were persuading to enter the vessel. [...] Good God! Margaret, if you had seen the man who thus capitulated for his safety, your surprise would have been boundless. His limbs were nearly frozen, and his body dreadfully emaciated by fatigue and suffering. I never saw a man in so wretched a condition.* [7]

Poor wee monster.

Poooooooor weeeee monster! Ill-cut and shabby. Clawed into consciousness from the bottoms of the pits. Dig you up viscous. Vicious. Worn out and soil-stained.

We see you. We see you. We hate you. Poor monster. We do.

Where are the wretched? And what? And who? Here

they are, picking at their stitches, undoing and unravelling, worrying at their suppurating seams. I see you, I see you. Whining and weeping at your monstrous construction. Poor wee monster.

Poor wee monster!

What is your name? No 'nom', just 'non'—there is no one to bring you into language. Unauthored, unmade; teron, teron, teraton, teraton. There is no story to begin your story. We will call you monster.

The captain writes:

> *I never saw a more interesting creature: his eyes have generally an expression of wildness, and even madness; but there are moments when, if anyone performs an act of kindness towards him, or does him the most trifling service, his whole countenance is lighted up [... We] asked why he had come so far upon the ice in so strange a vehicle. His countenance instantly assumed an aspect of the deepest gloom; and he replied, 'To seek one who fled from me'.* [8]

In the forgotten story that begins the story I can no longer distinguish between the monster and its maker.

Teratological. Topsy-turvy.

Poor. Wee. Monster.

ENDNOTES

1. Mary Shelley, *Frankenstein; or, the Modern Prometheus*, [1818], London, Dent: (Everyman's Library), 1967 [1912], p. 3.

2. *Frankenstein*, p. 5.

3. *Frankenstein*, p. 7.

4. *Frankenstein*, p. 10.

5. I had such a dream as an art student, the night of the completion of my first, bad attempt at a painting from life. In the life room, on the canvas, the male model, was constrained by the orthodoxies of the academy inside the safe borders of the 'nude'. In the dream the figure entered the territory of the naked, following me like a terrifying revenant, paint dripping from distorted limbs.

6. *Frankenstein*, p. 12.

7. *Frankenstein*, p. 13.

7. *Frankenstein*, p. 14.

Acknowledgements

'Over, In, and Under: after Über Dekkerinnerungen': excerpts of an early draft were published in *3:AM Magazine* 2015, and in *Existentialism*, ed. The Mekons, Portland, OR: Verse Chorus Press, 2017.

'Violet' was first published in *The Dreamers*, ed. Sharon Kivland, London: MA BIBLIOTHÊQUE, 2017.

'Manus' was first published in *On Violence*, eds. Rebecca Jagoe and Sharon Kivland, London: MA BIBLIOTHÊQUE, 2018.

'Poor Wee Monster' was commissioned as a performance reading for the opening of *i became what I saw* (2018), an exhibition of work by the artist and writer Kevin Lycett.

I am grateful to Sharon Kivland and Brian Lewis for their intellectual rigour, which has directly and indirectly supported the writing of these texts.